D0860498

DRAWING
for Painters

BARRON'S

Drawing for Painters

Original title of the book in Spanish: *Miniguias Parramón—Dibujo para pintores*
© Copyright 2013 ParramonPaidotribo—World Rights
Published by Parramon Paidotribo, S.L., Badalona, Spain

Production: Sagrafic, S.L.

Editorial Director: María Fernando Canal
Editors: Mari Carmen Ramos and Tomàs Ubach
Text: Gabriel Martín Roig
Exercises: Gabriel Martín and Óscar Sanchís
Editing: Roser Pérez and Tomàs Ubach
Collection Design: Toni Inglès
Photography: Estudi Nos & Soto
Layout: Estudi Toni Inglès

Translated from the Spanish by Michael Brunelle.

First edition for the United States, its territories and dependencies,
and Canada, published 2013 by Barron's Educational Series, Inc.
English edition © 2013 by Barron's Educational Series, Inc.

All inquiries should be addressed to:
Barron's Educational Series, Inc.
250 Wireless Boulevard
Hauppauge, New York 11788
www.barronseduc.com

ISBN: 978-0-7641-6576-4
Library of Congress Control Number: 2012948373

Printed in China
9 8 7 6 5 4 3 2 1

POCKET ART GUIDES

DRAWING
for Painters

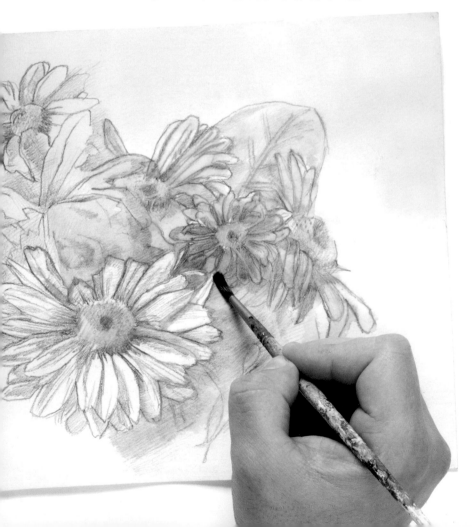

Contents

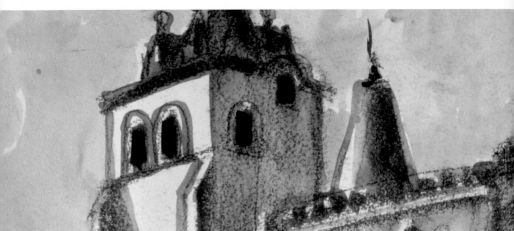

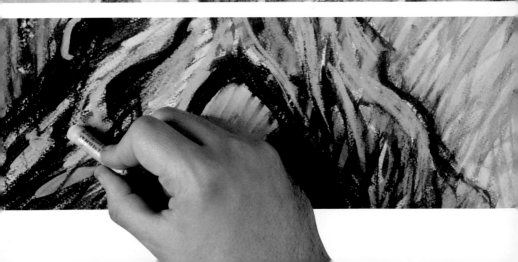

Introduction: Drawing: The Foundation of the Painting, 7

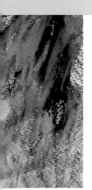

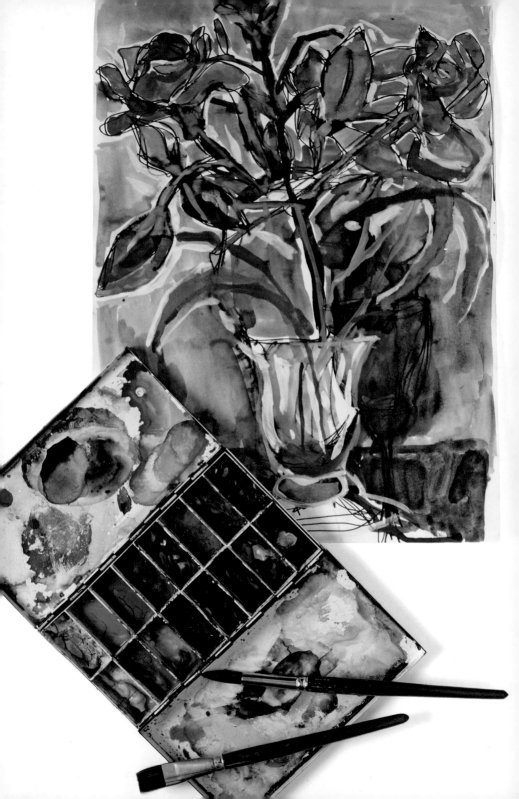

Drawing: The Foundation of the Painting

D rawing is the foundation of painting, from figurative to abstract, in any of the ways an artist chooses to express him- or herself. It is the basis of all artistic creation, and when applied to painting it has a clearly exploratory intention. Its principal function is observation, problem solving, and composing the subject. The lines applied at the beginning of the process will eventually become colored masses. Therefore, carefully planning the drawing is a first basic step when starting to work on a painting.

Many painters tend to leave drawing aside, out of carelessness, respect, or because they think that the layer of paint will hide or correct any mistake, disproportion, or incorrectness. Therefore, what frequently happens is that the final work reflects the absence of a well-established preliminary drawing. So then, the careful laying out of a drawing is a process that all artists should know well, and master if possible.

The execution and finalizing of a drawing by adding or painting over it with pigments and colors transforms the initial drawing for the painting. However, sometimes it is very difficult to see where the "painting" begins and the "drawing" ends. This is because the same tools are used for both, although the operations and the intentions may be very different. Today painting is less academic and more daring, and it rejects the more staid and traditional concepts. Works of art are more of a hybrid, and drawing and painting seem to lose themselves in a sort of promiscuity. The strokes of oil or acrylic no longer completely hide the lines of the drawing but establish a premeditated dialogue with the strokes of charcoal, oil pastel, watercolor pencils, and other media. Thus the drawing is not always a preparatory

structure or an isolated technique but one that becomes a medium of expression that is integrated into the painting.

This book offers a very complete view of drawing for painters with our double perspective, one related to the structural base, where the drawing acts as a guide for applying color, and another where it remains visible and is integrated into the work, making for new forms of expression. The dominant character of the drawing and the ample opportunity for its study are a constant stimulus for creativity and learning. It is certain that the better the painter understands this medium and its many techniques, which is the basis for all artistic specialties, and the better he or she is at it, the more its presence will add to the work of art.

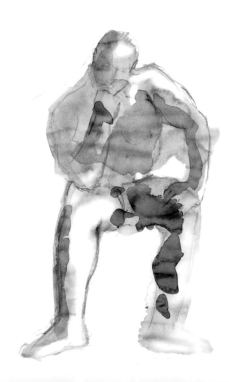

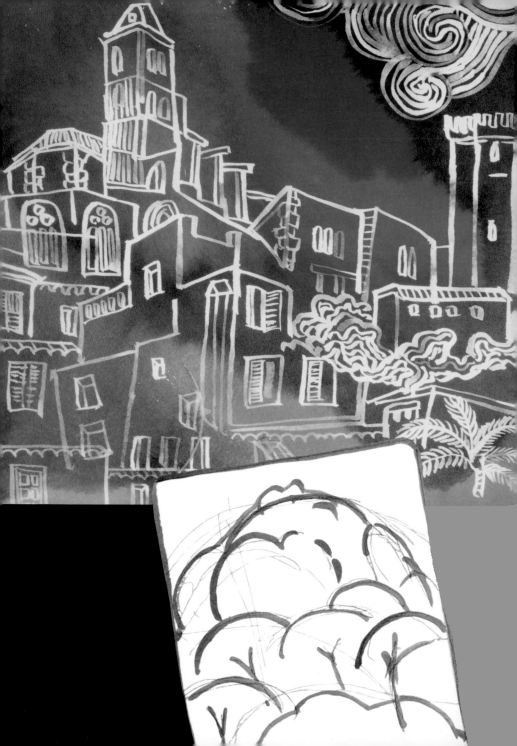

Techniques, Sketching, and Drawing

The sketch consists of a preliminary drawing based on a few simple lines that help you to see a complete, finished drawing. It is a construction composed of lines and shapes that reduce the complexity of the visible reality to a few geometric schemes, which organize the forms and establish a preliminary relationship of the sizes, directions, volumes, et cetera, which is the goal of capturing an essential form and creating a general idea of the drawing. The objective of the sketch is to recognize and retain, with a minimum of strokes and lines, the basic skeleton or structure of the model that you wish to represent. It never has a definitive character, since it is only the starting point from which the entire project will be developed.

Therefore, it must be simple and sparing in details; just a few lines will be enough to define the outline, the size, and the placement of each form. After this, organizing the color will play its expressive role, and you can modify the sketch as much as you wish.

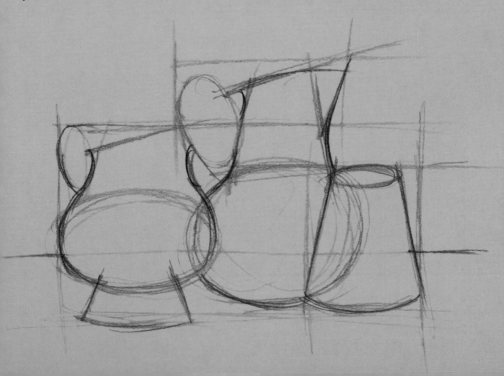

Estimating and **Measuring**

Drawing a round or square form is easy for any amateur artist. Where, then, is the difficulty? It is in skillfully combining the lines so that they are expressive. A poorly placed or applied line can cause the drawing to not make sense. Estimating and measuring help you analyze the model and place each line and its proportions on the paper in a balanced manner.

The first drawing can be done with a charcoal stick or with diluted paint. *In either case, the sketch should be highly stylized.*

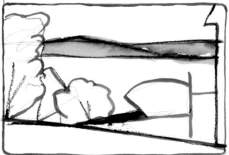

A cityscape is captured in a few diagonal lines *that allow you to sense the silhouettes of the most visible buildings.*

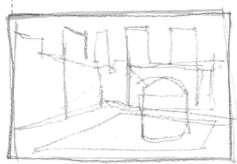

The sketch should be based on just a few shapes *that help distribute the different elements of the model on the surface of the paper. That is why the preliminary drawing looks so schematic.*

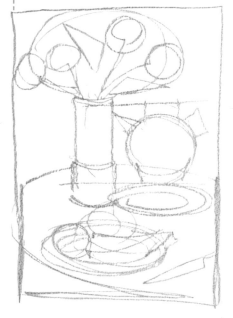

Blocking In

Blocking in is about learning to see proportions, translating what the eye sees to the paper in a balanced manner. This is done with a freehand preliminary sketch, with just three or four simple lines, reducing the blocking in process to a minimal impression, systematically modifying and moving this or that line until discovering the best possible representation. This way of working forces you to contemplate the model in a very analytical way and approach the drawing stylistically. This sketch will create a structure on which more precise forms can be developed.

Measuring and Checking Proportions

This is done by starting with a simple preliminary sketch, observing and comparing it with the original model. You must pay close attention, looking at relationships and making decisions about what you see, about the elements that you are focusing on. The need to be precise encourages the habit of measuring and relating shapes to each other before getting into the details. Measuring is done to make sure that the angles of the diagonal lines are correct, that the drawing shows the same relationship among the proportions as in the real model, and that the relationship between the objects and the space they occupy is the same.

A few marks and directional lines help construct the model proportionately and give order to the composition.

It is important to draw straight horizontal lines that will help establish references for measuring the various components of the models.

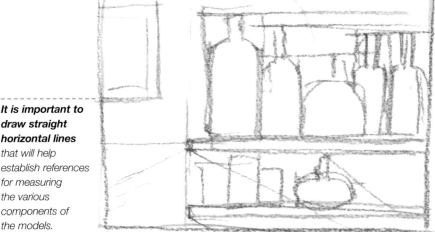

From Sketch to Drawing

After drawing several lines and making sure that the initial blocking in has created an accurate and well-proportioned representation on the support, you can begin to draw. Up until this point you have only a sketch, since a drawing is constituted by something more finished, precise, and definitive. Despite the freedom allowed by a sketch, some artists need to plan the composition a bit more, with grids or crossed lines that help give the model structure from a compositional point of view.

A preliminary sketch has just a few lines. Frequently this type of drawing is not very exact and is only really legible to the artist.

During the drawing phase, the shapes in the previous sketch are developed until they look half finished, a good time to begin to paint.

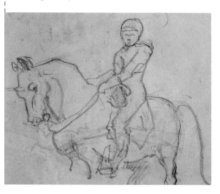

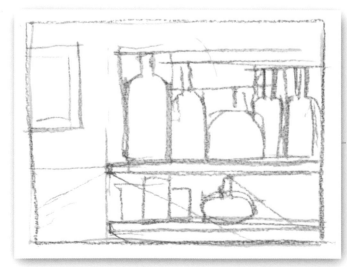

When painting, it is good to leave a space of about an inch or inch and a half around the margins.

Uses of the Preparatory Drawing

This partially elaborated drawing serves several functions. The main one is that it becomes a study, a starting point for another kind of work, in this case a painting that can end up as an oil, watercolor, or an acrylic. It can also serve to design new forms and compositions, modify the real model as desired by creating figures or spaces, and alter them to create a more subjective and personal representation. Representing reality does not mean creating a faithful copy of it but making a sort of re-creation of what you perceive rather than a replica.

Drawing for Painting

This type of drawing does not have to be too elaborate. It should follow the previously sketched lines. When you have arrived at the definitive shape, darken the main lines with a pencil or charcoal stick, leaving the lines visible, at least during the first phases of the painting. If you move things or modify them it is a good idea not to fill the space, that is, do not go too near the edges of the paper or the canvas. It is best to leave an inch or an inch and a half of margin; otherwise you run the risk that later corrections look cut off or slightly mutilated.

The sketch represents the greatest possible synthesis or abstraction of the model. It can be made by drawing a continuous line with the side of a pencil.

The shapes in the sketch are completed until arriving at a drawing that can be used for painting a watercolor. You may introduce some lines of shading that later will be integrated into the painting.

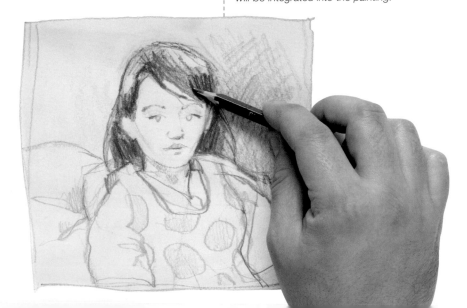

Geometric **Shapes**

Sometimes artists do not know how to approach a natural model, a photograph, or a scene because of its complexity. When facing such insecurity, the best way is to create a drawing based on very simple shapes or diagrams, identifying the geometric structures that will help to organize the experience in a way that it can be understood and better reflect reality.

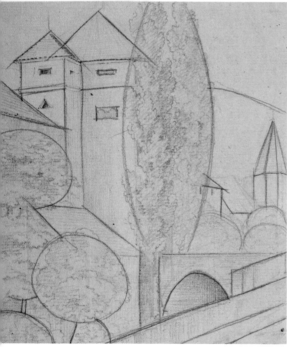

Interpreting a model based on geometric shapes helps to simplify the subject that may embody too many complications.

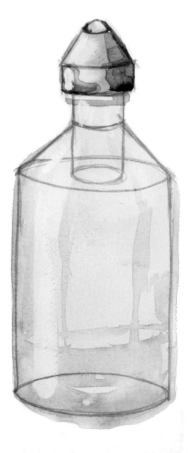

Any object can be simplified with geometric shapes. A sphere or a couple of cylinders make it easy to draw symmetrical elements.

Dividing the Model

When an artist is faced with drawing an excessively complex image, he or she must heed the old saying "divide and conquer," by dividing the model into smaller parts. Each one of those parts, in turn, can be reduced to a basic geometric shape, like a circle, rectangle, triangle, or a cone, that it resembles or can be compared to. This method can be understood as overlaying symbols or geometric figures on natural forms, and it helps you to understand and more easily remember the complex structures presented by some objects.

An Articulated Whole

By making use of geometric shapes you can deconstruct or disassemble any element that you wish to represent. Then it is a matter of seeing the drawing as an articulated whole that can be developed simultaneously in all of its parts, without one becoming more important than another. In this way natural elements can be translated or interpreted by means of geometric figures that help measure and verify the form and its proportions. While you are reducing the model to geometry it is possible to use extra lines that are horizontal, vertical, diagonal, and tangent, as well as make use of intersections and intermediate spaces for the same purposes of measuring and checking.

This painting has been blocked in with a graphite pencil. The seemingly irregular structures of the garlic have been resolved with two triangular projections.

The geometric preliminary sketch disappears when the paint is applied. The lines should not be visible, since the function of this sketch is as a planning aid, and it is not an intrinsic part of the drawing.

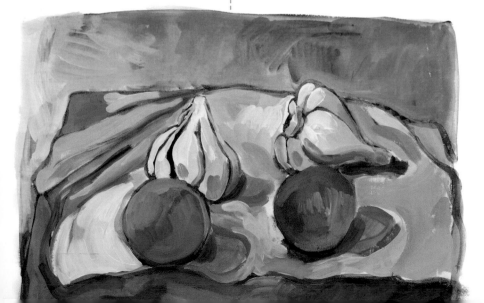

THE SUBJECT

Drawing with a **Brush**

Preliminary sketches made with charcoal can be preserved with a spray fixative or even directly with diluted paint applied with a brush. Any new correction can be made by going over the line with a brush without having to erase the original lines. The brush lines do not follow the previously made lines or the physical edges of the objects; they move across forms and go into space to unite, organize, and measure the integral parts of an object or a composition.

The initial drawing for this gouache painting was done entirely with brush and ink. After it has dried the intense black lines of the drawing are integrated into the painting.

Using a brush with a rounded tip charged with ink the artist made a quick drawing of these leaves on a branch.

Strokes of very diluted oil paint are used to fix the charcoal, and they are immediately wiped with a rag to help them dry and slightly blur the lines.

Reinforcing the Drawing

The tentative lines that were originally drawn are visual estimates that can be approved or corrected. A good way of preserving the drawing is to charge a brush with very diluted paint and trace the previously drawn line, correcting it if necessary. This means that if you have noticed some area that could be corrected, the modification is done directly with the brush. During this continuous process of intensification the lines of the object or its surroundings are constructed little by little, as you move them toward the correct density and value.

Fixing the Pigment

The brush is used to preserve the drawing made with pencil, chalk, or charcoal, fixing their powdered pigment to the support and ensuring that the purity of the colors of future applications will not be affected by the remains of the black charcoal. You can wipe it with a rag, so you do not have to wait for the strokes of paint to dry completely, especially if you are using diluted oil paint. You must proceed confidently, because although you may cause the lines to run or blur slightly, the drawing will not disappear.

If you draw directly with a brush and diluted oils, it is a good idea to begin with a very light color that can be easily corrected.

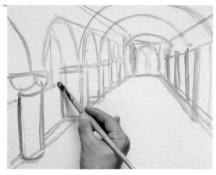

The entire sketch was completed with the same diluted blue and a fine brush. There is no need to erase any lines, those that you do not like can be corrected by adding new brushstrokes.

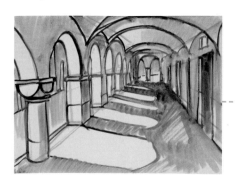

As the drawing becomes more defined, the weak blue lines are completed with additional darker ones. If necessary, these lines can be used to correct the earlier light blue ones.

Drawing for **Watercolors**

Watercolor is a transparent medium that does not cover or create opaque areas of color, and it is very likely that the lines of the drawing will be visible when the work is finished. This means that the preliminary drawing should be well thought out. The basic idea of a drawing for a watercolor is discretion and simplicity, because it usually occupies a second plane, completing the preeminence of the colors and brushstrokes.

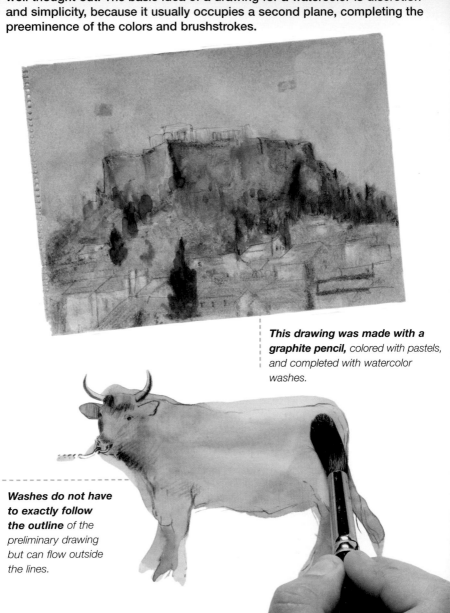

*This drawing was made with a **graphite pencil,*** *colored with pastels, and completed with watercolor washes.*

Washes do not have to exactly follow the outline *of the preliminary drawing but can flow outside the lines.*

Transparent Paint over Lines

A wash consists of using a brush to apply paint diluted in water in different proportions. The technique ranges from applying large areas of color to indicate zones, to light brushstrokes that highlight drawings made in pencil. When used as a medium for shading and illuminating the drawings, washes function in an accumulative manner, by adding layer upon layer. You begin with the lighter values and then continue by progressively adding darker ones, moving from light to dark. The transparency of the layers produces delicate and luminous effects. The initial drawing will even be there when the work is finished.

Pencil Drawings for Watercolor

The drawing should not be excessively finished, forming a group of closed outlines, but linear, suggestive, and economical. It should not indicate shadows or additions that are not completely necessary for the forms. All that is already well understood need not be emphasized. The fundamental reason that it is not a good idea to make an overly finished drawing in the first steps of a watercolor is that the most interesting thing about the forms is that they coincide with the paint. The natural edge of the brushstroke and that of the form represented by the brushstroke should seem to be the same. A rigid drawing constrains the brushstrokes and drains the expressivity from the painting.

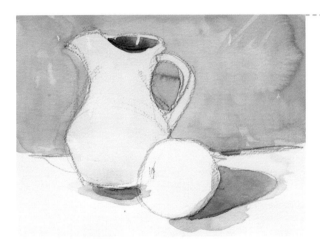

The pencil drawing is a necessary step when painting with watercolors. It is helpful for distributing and distinguishing the different areas of color.

Watercolor paint is translucent and reflects the white of the paper, which allows washes to create colors that are luminous and delicate at the same time.

The preliminary drawing is still visible after the painting is finished. Many layers of washes are needed to make the lines come close to disappearing completely.

Pencils for **Watercolor**

Preliminary drawings for watercolor paintings are usually made with graphite pencils, because their light gray tone and delicate line allows them to easily and discreetly blend with the colors. While lines made with graphite pencils resist diluted watercolor paint when it accumulates excessively, lines drawn with watercolor pencils, especially those of high quality, will dilute and create bursts of color. These pencils increase the possibilities in mixing colors.

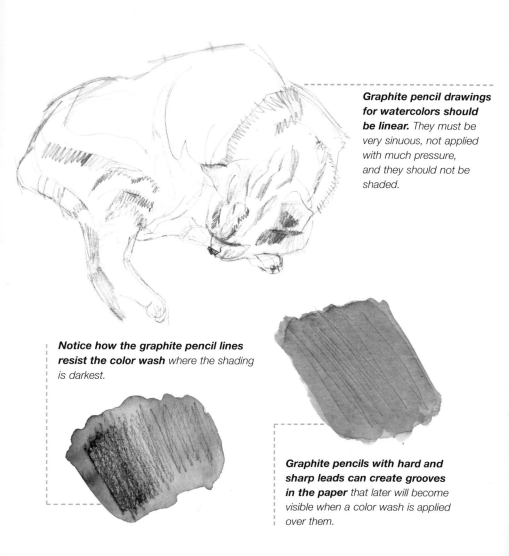

Graphite pencil drawings for watercolors should be linear. They must be very sinuous, not applied with much pressure, and they should not be shaded.

Notice how the graphite pencil lines resist the color wash where the shading is darkest.

Graphite pencils with hard and sharp leads can create grooves in the paper that later will become visible when a color wash is applied over them.

What Pencil to Use?

Artists typically use a soft graphite HB or 2B pencil, although many prefer pencils with harder leads, like H or 2H, because they feel that the lines drawn with them will not be visible when the work is finished. However, hard leads can be a problem since the sharpened points of the harder pencils can easily score the surface of the paper or cause grooves and scratches. There is a chance that these marks might retain water and paint and create lines that are too visible. Therefore, if you decide to use them you should be very careful and draw by applying very little pressure on the support. It is better to use a 2B, and if you are bothered by the permanence of the lines, you can partially erase them before painting.

Watercolor Pencils

These pencils allow you to dilute the lines of the preliminary drawing. This medium combines many of the qualities of traditional watercolors with those of graphite pencils, with which you can create a wide range of expressive effects. They give the artist all the flexibility and potential expressiveness that a line can offer, and the ease of creating tones, light and shadow, and color by brushing the lines with a damp brush. The dark pencil lines stay in place and are visible through the wash, but if you work on damp paper they are softer, spread, and even blend.

Lines made with watercolor pencils turn into watercolors when a brush full of water is passed over them.

When you dampen the lines of a drawing made with watercolor pencils you create a perfect blending of the drawing and the painting. The color becomes more important without the pencil lines completely disappearing.

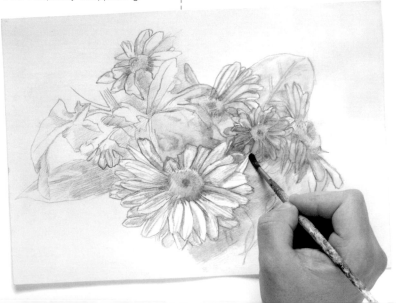

Color Pencils
and Watercolors

When the model is an animal, it is a good idea to wait until it is sleeping so you can work at a relaxed pace.

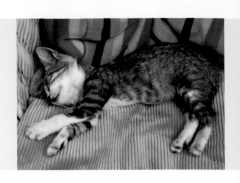

1. Sketch the principal lines with a graphite pencil: the space that the body will occupy, the head, and the angles of the legs… The line should be very light, made with very little pressure.

2. By working roughly and progressively you will achieve a simple but accurate drawing of the kitten. Use only lines, and avoid any shading.

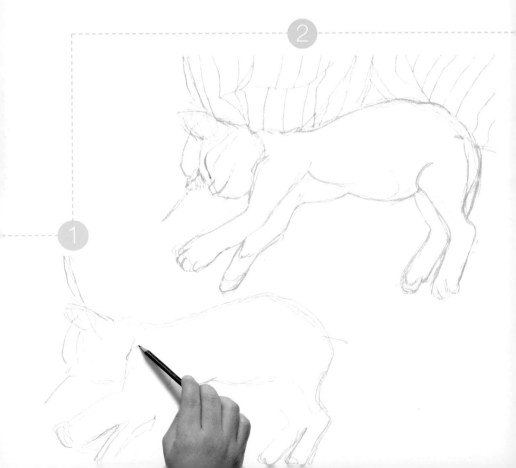

In the following exercise you will explore the combination of line and wash. First, make a preparatory drawing that will later be blended and integrated into the watercolor. Different media are used to draw the lines: graphite pencil, watercolor pencils, and a white wax crayon.

The main challenge of working with line and wash drawings rests in achieving a unity between the two media. These drawings suggest much more than are actually revealed in them, and they have more defined and precise outlines.

4. After drawing over the graphite lines with the watercolor pencils, you can begin to apply some washes. Charge a brush with just water, and carefully dilute the color lines.

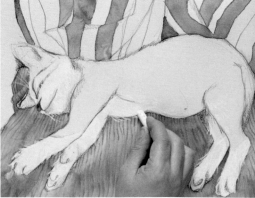

3. Do some more detailed work with the watercolor pencils, strengthening the outline, extending some shadows, and applying hatch lines to simulate the fur.

5. When the pink washes have completely dried you can finish the drawing. This time draw with the white crayon to resist the watercolor in the spaces that should remain white.

6. *Apply some light brown washes to the kitten's head with a round ox-hair brush. They will incorporate some additional colors when they are dragged across the gray and blue pencil lines.*

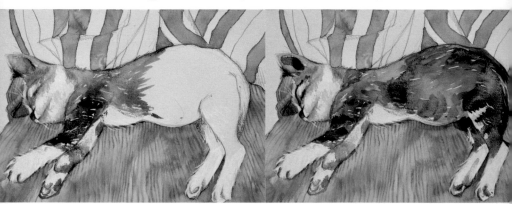

7. *No matter how much you paint over the areas covered with crayon, the color will not adhere to the white reserves. Add some gray to the brown as you advance along the kitten's body.*

8. *Leave small bare areas unpainted along the whole body of the kitten to better indicate the fur. The pencil lines that define its outline are still visible.*

9. *While the surface of the paper is still wet, paint the dark stripes in the fur that characterize this breed. The strokes of color will slightly blend with the colors underneath.*

10. *After the painting has dried completely you can paint the stripes on the pillows with transparent washes of blue, green, red, and burnt umber.*

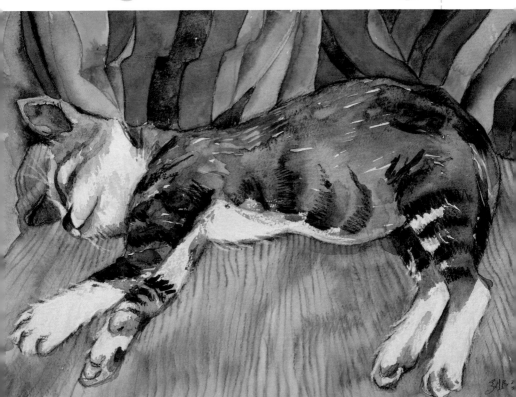

Preliminary Drawings for **Oils and Acrylics**

This type of drawing is usually done with charcoal, although other materials are not to be ruled out, like graphite sticks, oil pastels, and conté pencils. All of the dry media should be used with moderation, without shading or pressing the stick against the canvas with too much pressure, which could loosen the stretched canvas, make a hole in it, or saturate it with pigment. Charcoal and its derivatives should only be used for medium- and large-size canvases, where the roughness of the charcoal line will not be a problem.

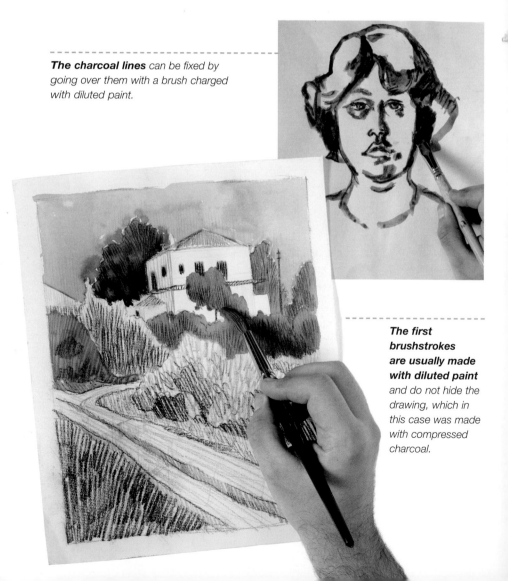

The charcoal lines can be fixed by going over them with a brush charged with diluted paint.

The first brushstrokes are usually made with diluted paint and do not hide the drawing, which in this case was made with compressed charcoal.

Charcoal and Paint

The preliminary drawing for an oil painting should be light and sparing in details. A few lines that roughly define the outline, the size, and the placement of each shape will be enough. These lines can be fixed with a spray (if the color work is to be delicate) or left as is if you plan to use opaque paint from the beginning. The charcoal makes a very intense line and should only be used when the artist is willing to work with the black lines of the drawing, which are impossible to hide until the end of the painting process. When the line must be stronger, it is best to use compressed charcoal whose darker tone makes the lines stand out more than vine charcoal. The drawing should be completely incorporated into the scene and not clash with the color at all.

A Messy Medium

When artists use charcoal for drawing, they should make sure it does not muddy the colors. The lines can be fixed on the support by painting over them with either oil diluted with thinner or acrylics diluted with water. It is not recommended to shade the preliminary drawing; however, if the shading is light it can be fixed with turpentine or a spray fixative before painting. Before dampening or fixing the charcoal lines, it is important to wipe the support with a clean rag to keep the soot particles from muddying the paint. Many artists like to make a light wash first, like a watercolor, with translucent applications that allow the lines of the drawing to show through. This requires working with a lot of solvent, using thick paint for the final touch-up.

Lines made with charcoal are quite volatile and blend with wet paint.

The soot or dust caused by the charcoal lines can muddy the colors if they are not fixed first.

The lines made with compressed charcoal are more intense and permanent. The line remains, despite applications of wet paint.

Egon Schiele
(1890–1918)

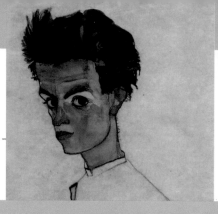

Despite his premature death, Schiele was one of the foremost exponents of Austrian Expressionism.

The Artist's Room in Neulengbach, *1911.*

It is presumed that this work known as The Room *or* The Artist's Room *is a small homage to Van Gogh. It forms part of a series of paintings where common elements of his surroundings became the models for his work. He used them to express his loneliness and his frustrated desire to have a family. His palette consisted of earth tones and came close to lacking any color. His quick strokes of diluted paint, with a layer of translucent paint, allows the preliminary drawing to be seen. The pencil lines are integrated into the work and illustrate the artist's highly depressed state.*

1. *Draw the perspective lines to define this interior with a stick of charcoal; first with thin light lines, and then go back over the shapes of the elements with a heavier line.*

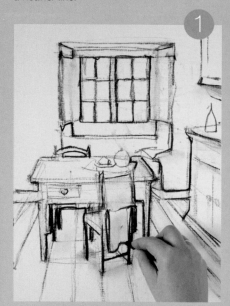

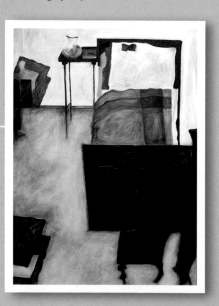

A PALETTE
FILLED WITH
EARTH TONES

Egon Schiele died at twenty-eight years old, a victim of the Spanish flu epidemic.

Along with artists like Gustav Klimt and Oskar Kokoschka, he was one of the most outstanding representatives of abstract expressionism. His work has heavy incisive lines that highlight the drama of the shapes of the figures, the objects, and the interiors he painted. The color becomes a complement that adds substance to the lines, and he did not use it in a natural way, many times grayed, unsaturated, and contaminated with brown and ochre tones.

2. Wipe the drawing with a rag to reduce its intensity. Use very diluted gray and ochre paint to cover the walls and the floor of the space, leaving the furniture white.

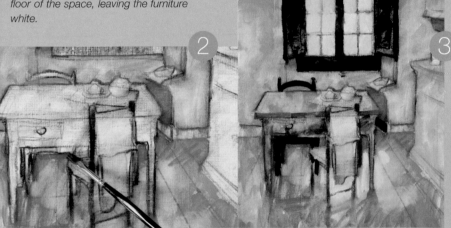

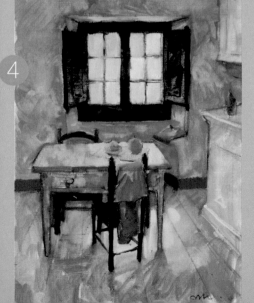

3. Paint the darkest areas first with very diluted raw umber and ivory black. We recommend using a fine round brush with soft hair for the delicate and precise work.

4. After applying the colors, which are very grayish, in each area notice how the initial charcoal lines are still visible. Do not worry about making them disappear; on the contrary, it is important to preserve them so that they blend with the thin layers of paint.

Drawn Lines with **Washes**

The preliminary drawing for any wash can be made with various tools. The characteristics of the drawing materials allow you to make distinct lines that, because of their varied consistency and intensity, offer different results when they are covered with acrylic

The lead gray color of graphite pencils blends well with washes, and they remain unchanged when dampened.

When applying a wash over charcoal lines the lines will lighten and lose intensity.

The ink from a ballpoint pen can be combined with watercolor, although it will run slightly and change color.

The lines made with watercolor pencils intensify and become wider when they come into contact with a wet brush.

or watercolor washes with varying amounts of transparency. On these pages we show samples and analyze each one, looking at the compatibility and successfulness of the many possible combinations of drawings and washes.

A drawing made with wax or oil pastel will repel the wash, and it maintains the vigor of the lines and the original color.

Drawing made on aniline ink using a reed or nib pen charged with bleach. After a few seconds the color will fade and leave the lines visible.

A preliminary drawing made with a brush has thicker lines and contrasts less. The color will be altered when washes are painted over it.

A metal nib pen is a very common tool. It can make a thin dark line over a dry wash, and a line with fine filaments over a damp wash.

Bleaching a Drawing Made with **Aniline Ink**

This still life shows interesting effects on the vase and the printed checkered pattern on the cloth.

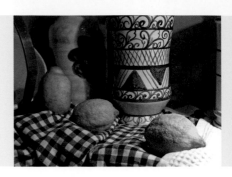

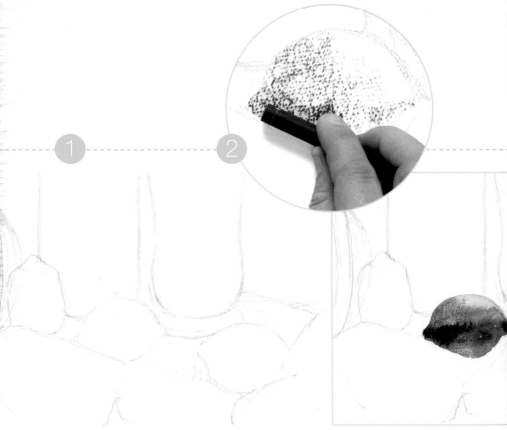

1. This light pencil drawing marks the outlines that will be filled in with ink. It is best to use a heavy-weight paper, at least 60 lbs. (150 gms), because the use of strong bleach could ruin the work.

2. The lemons are shaded with the side of a sienna wax crayon. It will make a grainy texture that will blend with the color of the wash.

The aniline inks, also known as liquid acrylics, are very saturated colors and have a strong coloring power. In this still life the decorative and printed elements are drawn over the dry watercolor with brushes and pens, using only bleach containing sodium hypochlorite, which has the ability to oxidize the ink until it is completely white. It is like making a drawing in reverse: the lines are not drawn at the beginning but at the end, and they will fade the layer of color with great precision, so you must be careful not to splash the surrounding areas.

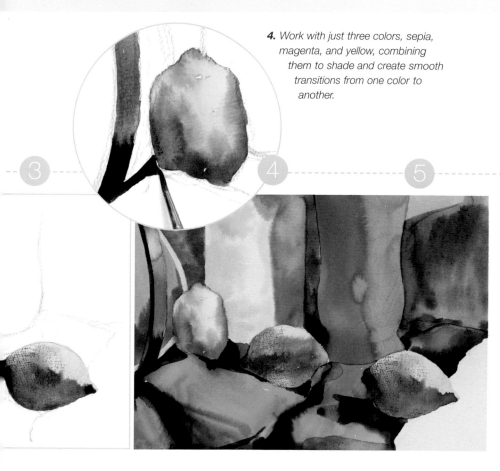

4. Work with just three colors, sepia, magenta, and yellow, combining them to shade and create smooth transitions from one color to another.

3. Paint the illuminated parts of the lemons with bright yellow. This color should be darkened with sepia brown as it moves toward the shaded half of the fruit.

5. You must wait until the first washes are completely dry to paint the background (with green and sepia) and the blue cloth (with touches of magenta and sepia). Use a large amount of water because the aniline colors are very intense.

6. Use a fine inexpensive brush to apply bleach on the decorated vase. The blue color of the ink will quickly begin to disappear.

8. Now open up the light areas that define the checkered pattern on the kitchen towel. You must pay careful attention to the shape and direction to illustrate the folds and creases.

7. Carefully paint the white areas of the vase with bleach, very carefully following the ornamental geometric drawing. It is more accurate to say that you are drawing with bleach rather than painting.

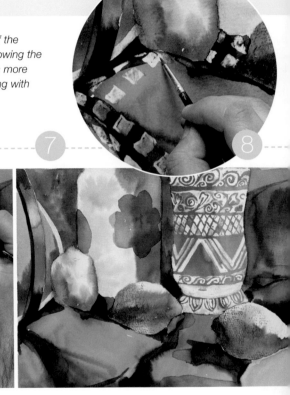

D R A W I N G I N R E V E R S E

9. *The final bits of drawing with bleach are made with a metal nib pen. Go over some outlines and add small hatching effects on the fabrics.*

10. *When everything has dried, add some areas of intense blue on the checks on the cloth to complete the effect. The bleach will have eaten away part of the brush, which you should discard.*

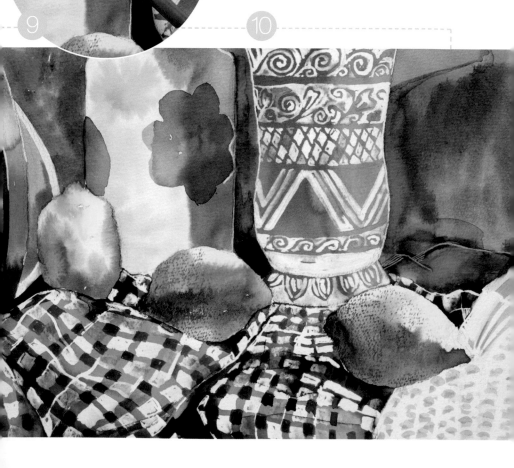

Subjects and Their **Particular Requirements**

Nowadays, artists can choose any kind of subject for painting from among the unlimited possibilities that exist. Having an attraction to a particular subject is a good source of motivation that will keep you actively painting. Many painters who specialize in landscapes or still lifes like to make occasional attempts at themes that are not usual to them and that they had previously rejected, thinking they required greater drawing skills. Testing your abilities against the challenge of more complex subjects, like the figure or urban landscapes, should inspire you. In this section, we have classified the most important artistic themes and accompanied them with observations and solutions to the main problems that each of them poses to the draftsman.

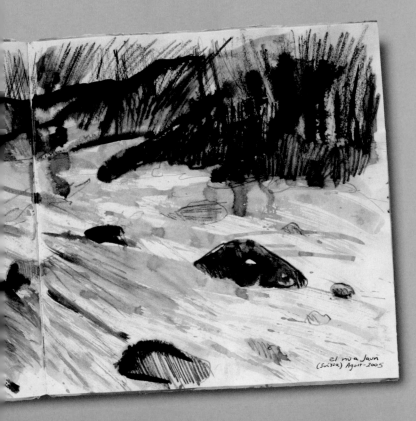

Still Life: From Geometry to Form

Still lifes are models consisting of everyday objects, whose immobility allows a patient and detailed study of all its components. The composition of a still life must reflect a balance between unity and variety. This means that the drawing should not group all the objects in the center of the painting, yet it should not be too scattered, with many free spaces and dispersed elements that are isolated and unrelated to each other.

The objects should be drawn loosely. *Initially it is better to consider them as if they were transparent or made of glass. This will help you draw them symmetrically and in proportion.*

Blocking in means drawing them within boxes, *or square shapes. The different objects are constructed based on geometric shapes.*

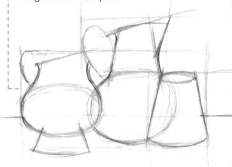

Draw the outlines more clearly over the sketch, *and make them stand out on a shaded background. The contrasts are important for clarifying the forms.*

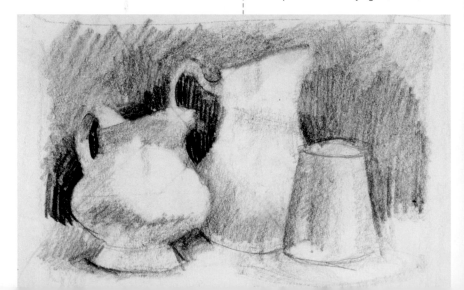

From the Simple Shape to the Object

The work of a still life begins by choosing and placing the objects. The artist must keep in mind the approximate shape of each element that will be represented by a very simply drawn geometric design. You can simply indicate the space occupied by each object and the relationship of its proportions created with the adjacent objects. When the distribution and the dimensions seem perfect, complete the form of each element to make it easier to identify. It is best not to leave too much space between them; otherwise the unity of the still life will be destroyed.

Drawing Glass

You must group the objects so that some are in front of others, which will give the grouping some depth. Place some objects close and others farther away so that the shapes that are created between them are varied and interesting. To make the placement of the objects easier they should be drawn as if they were transparent or made of glass so that those in the background are not hidden. This technique will make it much easier to draw a symmetrical representation of each object. Attention to the details should be left until later, when the drawing is completely laid out and developed. Finally, the light should be simply indicated. The shadows help give the objects solidity by anchoring their placement and controlling their light.

This drawing was constructed using geometric shapes. The applications of color blend with a base of charcoal shading.

A good sketch can be a point of departure for a subjective interpretation, where the black chalk lines are combined with acrylic paint.

Organizing the **Landscape**

A stroke of color is a tool that is just as powerful as a drawn line. It is suggestive, and it insinuates and efficiently evokes each part and aspect of a landscape rather than outlining it. Sometimes, when sketching a landscape, you will see that the view takes in a great number of details and shades that should not be included in the drawing. Trying to include the great profusion of textures in the vegetation in detail is a mistake that can be avoided if you follow a stylized or synthesized layout.

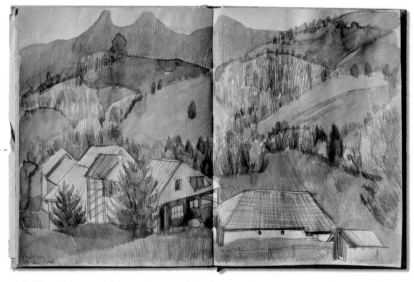

Strokes of diluted watercolor can be combined in a tonal work made with graphite pencils of different degrees of hardness. The paint typically flows freely over the edges of the drawing.

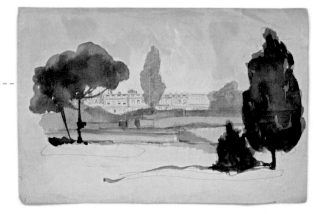

The intensity of the colors varies with the distance. The farthest areas are indicated with very diluted colors, while the near trees require darker paint.

A Few Strokes of Paint

Artists are not used to drawing a landscape exactly as it is in reality, and they often make some adjustments. Therefore, when drawing a landscape for painting it is a good idea to organize the forms in a way that directs the eye of the viewer across the drawing. You must find a way to relate the elements in the foreground with those that are farther away, highlighting the foreground with strong contrasts of light and shadow and making the background lighter.

Balance in the Landscape

The visual experience of balance occurs when the brushstrokes are distributed in such a way that they compensate for each other. The accents or impact of the strokes will be arranged from the strongest to the most subtle and delicate. The composition should be based on the relation of point to counterpoint, in the juxtaposition of various elements that achieve a certain balance. You must make sure, then, that the balance in the drawing will be determined as much by its arrangement as by the sum of multiple elements and the way that its presence is accentuated in the whole.

The strokes used to sketch the landscape should not be built up randomly and without thinking.

The strokes are a drawing in themselves: their edges and the variations in color can indicate each plane in the painting.

It is best not to stray from the structure but alternate brushstrokes that make some sense with white spaces.

A Winter
Landscape

This road that passes through fields and along the banks is covered with a fine layer of snow.

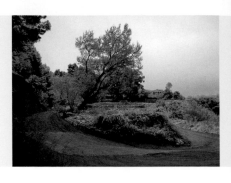

1. *A drawing made with charcoal pencil allows you to organize the composition with very few lines. Then, invisible lines are drawn with white wax crayon on the areas covered with snow.*

2. *When the first gray and brown washes are applied to the landscape, the crayon drawing resists the wash and is seen as a white line.*

3. *When the watercolor is half finished use the pencil again to create small contrasts and to add the detail of a house in the distance. If there happens to be too much wax, you can remove it by carefully scraping with a razor blade.*

W A X C R A Y O N L I N E S
R E S I S T T H E W A T E R C O L O R

Drawings made with wax crayon resist the watercolor paint and can be combined with lines made with graphite pencils or with charcoal to accurately represent climatic effects like fog, rain, or a winter landscape covered with frost or snow. If you work on a heavy-weight paper, the lines will appear broken and grainy, and their texture will contrast with the more or less homogenous washes of color.

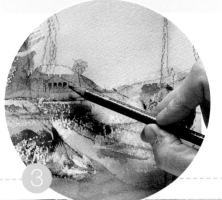

4. *Create new shades with burnt sienna, cobalt violet, and Payne's gray to contrast even more with the wax reserves. Notice that the charcoal lines are still visible in the finished work, communicating something about the creative process.*

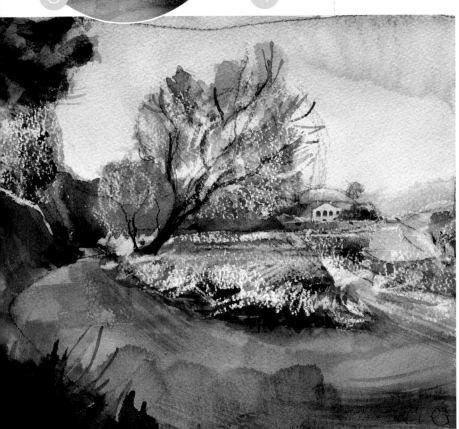

Interiors: **Creating Space**

At first, painting interiors can seem to be a boring activity; however, when you delve into the subject, it can be surprising how different they can be from each other and the challenges they present. The first interior that you should use as a model for a drawing should be one that is most familiar to you. The simplest way of representing it is to begin with a corner and project the lines that indicate the ceiling and the floor.

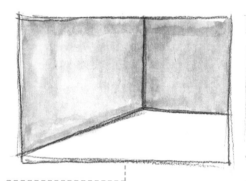

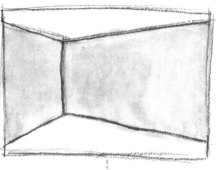

The best way to lay out an interior is to draw diagonal perspective lines from one of the corners.

Projecting both diagonal walls from the corner will indicate the placement of the ceiling and the floor.

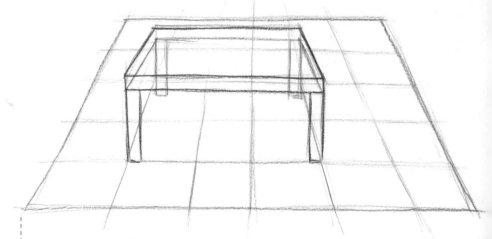

When a piece of furniture is not placed against a wall, you can project a grid on the floor of the room to draw an elevation of it.

Constructing the Edges

In a drawing of an interior you must first represent the perspective: the limits of the architectural space, meaning the lines that define the angle of the room, the floor, and the ceiling. It is best to begin by drawing a corner, from which diagonals are placed to indicate the top and bottom of the walls. You can cheat or deform the interior perspective a little, not making it too noticeable, so that the room can have an extremely wide angle of vision. Sometimes small spaces cannot be rendered with conventional linear perspective because the cone of vision is to narrow. In such cases you must resort to exaggerating the angle to create a feeling of involvement and place.

Furniture on a Grid

Once the space has been rendered, the best way of situating pieces of furniture in the room's interior is to treat them as if they were simple geometric shapes. The furniture that is up against the wall does not present much of a problem since the lines of the wall make it easier to block in, but the pieces that are in the middle of the room require the use of a grid. To make a more or less coherent grid, lay out the floor as if it were a chessboard. Divide the walls into equal parts, and then join each division with its opposite. The resulting grid is then used as a guide for drawing new geometric shapes that will end up as the furniture. You must draw the objects as if they were made of glass.

First draw the corners with perspective lines to establish the walls.

The furniture is rendered as if it were simple geometric shapes in perspective, basically cubes and rectangular objects.

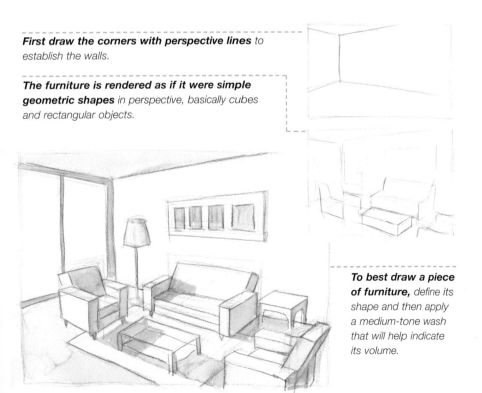

To best draw a piece of furniture, define its shape and then apply a medium-tone wash that will help indicate its volume.

The Challenge of an **Urban Landscape**

The image of a city is a very attractive subject for any painter, since the same scene can be made up of many different elements: the individual buildings that establish landmarks and points of reference in the outline of the city, its materials, textures, colors, the surrounding geography like plazas, parks, and the contrasting vegetation. The greatest problem that the artist faces is the perspective of the buildings.

There should be a gradation in the representation of an urban landscape that has an effect on the tones and the thicknesses of the lines, depending on whether you are drawing buildings that are near or far away.

Any architectural form can be synthesized in geometric basic shapes. It is a matter of choosing the most appropriate one for each case.

The closer geometric shapes are completed with details and textures that create the definitive appearance of the buildings in the foreground.

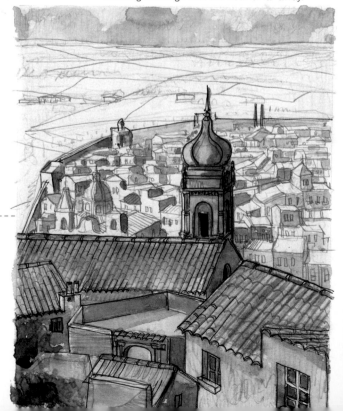

How to Construct a Building

To simplify the challenges in drawing buildings, especially the most complex ones like cathedrals and palaces, your sketch should be reduced to basic geometric shapes. Any construction, no matter how complicated, can be seen as a series of large connected blocks and cylinders. Once these shapes have been identified in the model, the building can be constructed by gradually adding the architectural details. The subject presents certain difficulties, but it is not necessary to be an expert at drawing more or less accurate simple geometric shapes in three dimensions.

Differentiating the Grounds

Just like in the natural landscape, the key to representing an urban scene rests on the differentiation between what is near and what is far away. The simple representation of some objects in front of others will create a sense of depth. When similar objects are drawn in different sizes, the larger ones seem to be closer than the others. These intuitive representations of depth are often enough to resolve rural scenes or urban ones with few buildings. But when it is a matter of organizing spaces with many buildings, you must make use of linear perspective, because it is not possible to make a coherent drawing without using a system that determines the heights of the views in perspective.

The well-defined shapes of the constructions in the foreground allow you to create compositions with a stronger feeling of depth.

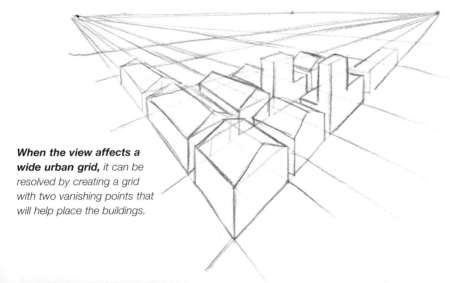

When the view affects a wide urban grid, it can be resolved by creating a grid with two vanishing points that will help place the buildings.

THE SUBJECT

Visual **Perspective**

This is drawn freehand, without measuring and based on the artist's intuition, and it can be used to construct an urban scene with a convincing perspective. Perhaps the finished drawing does not closely follow the rules of mathematical perspective, but the final result should be believable and leave no doubts nor create spatial confusion. It is easily sketched by making light lines and using quick movements of the arm that helps in drawing more or less straight lines.

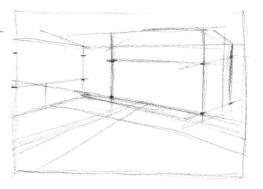

The perspective of any urban scene is drawn freehand. The buildings are sketched as shapes deformed by perspective.

The architectural details of the façades are defined, and the trees are superimposed over the preliminary sketch. This drawing is all that is needed to begin painting.

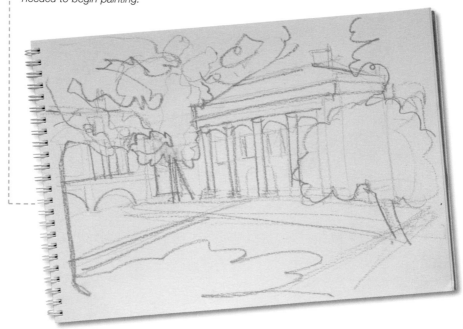

Angles of the Façades

The drawing of an urban space begins by drawing a straight perpendicular line in the corner of a plaza or of a building. Diagonal lines are projected from this straight line, and their angles should be measured by eye. The parallel lines that in reality are found in the streets and buildings become diagonal lines that converge toward a single point. These diagonals limit the heights of the buildings and become the guidelines for the angles of the buildings and their diminishing heights in the distance. This creates a geometric scheme to which the architectural details can be added by following the direction and sizes dictated by the lines.

Fan-Shaped Diagonals

When drawing the elements on the façade, like doors, windows, lintels, etc., it helps to understand that between the diagonal line that indicates the top of the building and the one that marks the base, the arrangement of the intermediate diagonal lines is radial; they are arranged in a fan shape. When the vanishing points of these lines are outside of the space in the painting, you must divide the vertical lines (the corners of the building) into an equal number of parts (this can be done by eye since it is an approximation). Diagonal lines are drawn freehand from these points. Then you must make sure that the windows and the doors line up with the diagonal lines that divide the façade.

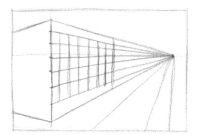

To use visual perspective, it is necessary to have a basic knowledge of perspective to be able to produce convincing architectural drawings.

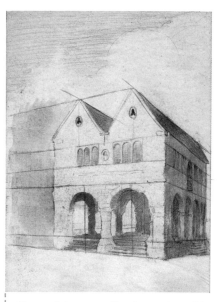

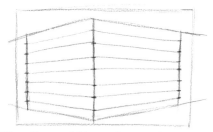

When the vanishing points are located outside of the paper, the corners of the buildings should be divided into the same number of parts, and then all the points are joined with diagonal lines.

Two-point perspective is most used in drawing urban spaces, and just as in drawing interiors the lines of perspective begin at the corners of the buildings. They are distributed on the façades in a radial pattern or a fan shape.

Alleyway with
Charcoal and
Oil Glazes

An alleyway is a perfect model for making a drawing using visual perspective.

1. Draw the architectural structures using a stick of charcoal to make the lines.

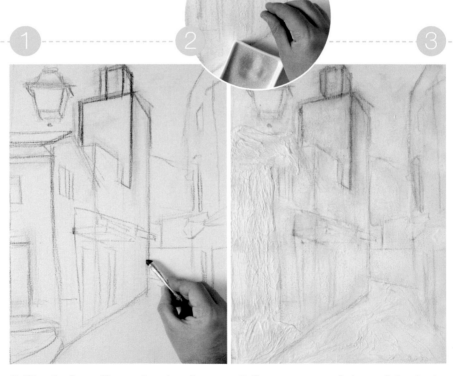

2. Wipe the lines with a rag to reduce the intensity of the lines. Cover the surface of the paper with thick latex glue, and sprinkle on a few fine glass beads so they will adhere to it.

3. Tear up some small pieces of absorbent paper, like toilet paper or paper towels, and stick them on the paper, making sure they are somewhat wrinkled and pressing them with a brush charged with latex. Then begin painting when they have dried.

A good layout and synthesized forms are the basis of the following perspective drawing. It will help you overcome the difficulties that arise in reading the forms. Use visual perspective to create the preliminary drawing, which will be completed with large areas of diluted oils and some textural effects that will be created with wrinkled paper and fine glass beads. The final linear touches are made with a stick of black chalk while the paint is still wet, so the chalk is absorbed in it and will stay there after it dries.

A GOOD LAYOUT

5. The textural effects become more visible when the diluted paint is added. The lightest parts of the buildings are left unpainted.

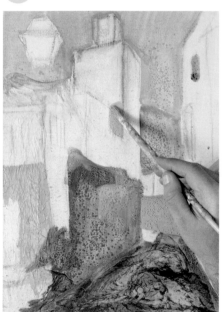

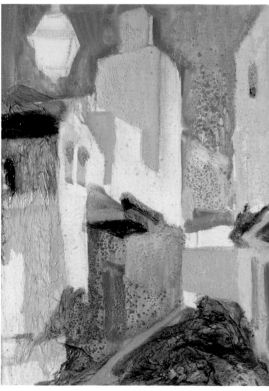

4. The lines of the preliminary sketch are excellent guides for applying the first diluted brushstrokes. Begin with the blue sky, and continue by resolving the shaded areas.

6. *The applications of color will progressively become smaller and less diluted. You should begin indicating doors and windows, but loosely and even a bit roughly.*

7. *In this phase, the additions of oil paint have finished. Notice that the treatment is very stylized, but it works to explain the architecture and the distribution of light.*

8. *Add some drawing back into the painting. Make some very fine and light lines with black chalk on the still-wet paint. When the oil paint dries it will assimilate the lines and make them permanent.*

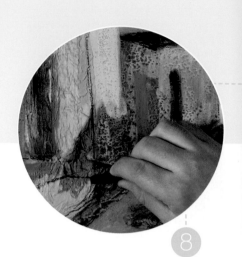

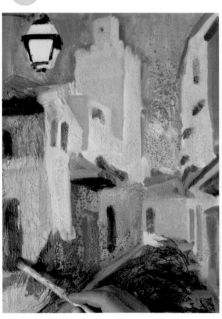

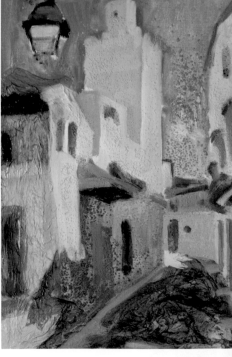

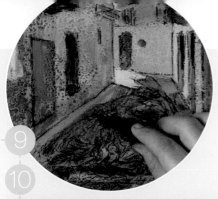

9. Rub the side of the stick of chalk on some surfaces to emphasize the effect of the texture a bit more, if needed.

10. Draw the cables that hang above the alley with the tip of the chalk. All that is left is to illuminate the façade on the left with a layer of thick opaque white oil paint.

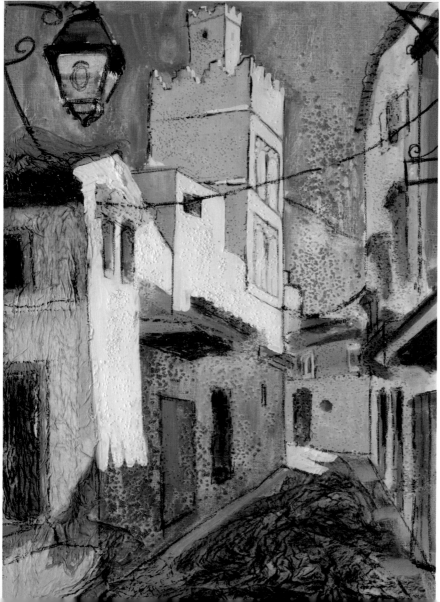

Several Ways of Drawing
Lines with Oils

When you are going to make a preliminary drawing for an oil painting, it is important to be knowledgeable about the drawing media; in other words, know exactly how it reacts to and mixes with the paint. This choice should be very carefully made, keeping in mind just how large a part the

Charcoal lines are intense, but they fade with water-base paints, and they can even muddy the colors.

To keep the charcoal from muddying the colors, you can fix it by painting over it with paint diluted with turpentine and allowing it to dry.

Graphite makes a grayer line, but it will last longer than charcoal. It will not bleed or become diluted.

Color pencil, whether it is water soluble or not, makes a colorful line. It barely becomes diluted when painted over with turpentine and paint.

drawing will play in the final work. Here we show some examples of how lines made with different drawing media bleed and become diluted, or not, when painted over with oils diluted with turpentine. This will help you better understand the compatibility between materials.

If you make the preliminary sketch with oils diluted with turpentine, you should wait at least a half hour before adding a new layer of paint.

A wax pencil or crayon has a large amount of wax that isolates the pigment from the diluted paint, so the line will resist any kind of wash.

Pastels use oil as an agglutinate, so there is a chance that the lines will run a little and discolor the paint on top of it.

Oil pastels make a very fat, greasy line; a light pass with a brush charged with turpentine is enough to dissolve it.

Eugène Delacroix
(1798–1863)

Delacroix used the lead pencil as much as the pen, and watercolor washes with consummate skill.

Unmade Bed, *1816.*
Delacroix always carried a sketchbook in which he drew the subjects that caught his attention, things that he found around him. First he would make a pencil drawing, and later he would color it with watercolors. This unmade bed, made when the artist was a youth, was recently discovered after spending years hidden in a folder. The folds of the sheets are represented in an almost obsessive manner, creating a composition where the contrast between light and shadow becomes very important. The successive watercolor washes describe the volume of the draped fabric with a very limited range of colors against a dark background that reinforces the strength and illumination of the subject.

THE FOUNDATIONS

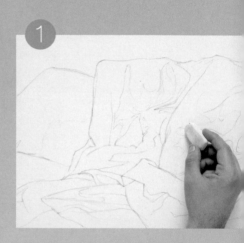

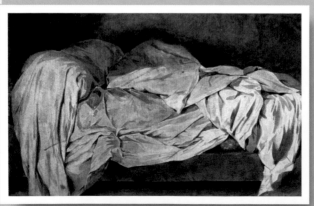

1. The preliminary sketch is drawn with a graphite pencil, representing each fold and wrinkle. An eraser is used to reduce the intensity of some of the lines.

This precocious and outstanding artist entered the School Of Fine Arts in Paris at 18 years old. There he met Theodore Gèricault and Raymond Soulier, who introduced him to watercolor painting. In his work, which is induced with a strong romanticism, he alternates a Baroque dynamism with a free and daring brushstroke. He used color as the essential means of expression, and he modeled the masses of his subjects with strong light and shadow. His use of color and contrast creates a very sculptural look to the surfaces. His loose brushstrokes cause the paint to vibrate and increase the sense of movement.

OF IMPRESSIONISM

2. The first application of watercolor is very light, mainly serving to mitigate the pure white of the paper and apply the first shadows on the main folds. A diluted mixture of blue, crimson, and Payne's gray is used.

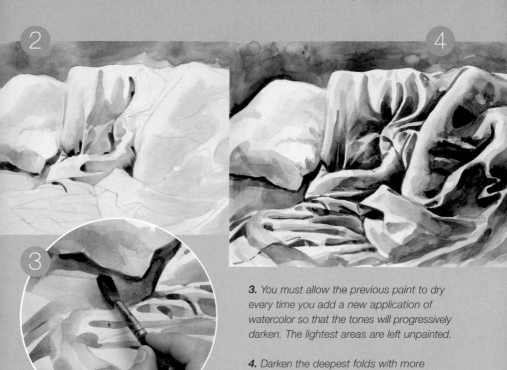

3. You must allow the previous paint to dry every time you add a new application of watercolor so that the tones will progressively darken. The lightest areas are left unpainted.

4. Darken the deepest folds with more saturated Payne's gray; this will increase the relief effect on the draped fabric. On the lightest areas, like the pillow, the gradations should be much more subtle.

Capturing **the Figure**

Drawing the human figure, whether dressed or nude, is without a doubt one of the most complicated subjects for the amateur artist. This is because the proportions of the body are so familiar to us that it is difficult not to find frequent errors in our drawings. An inexperienced draftsman usually constructs the figure with rectangular and oval modules that suggest different parts of the anatomy.

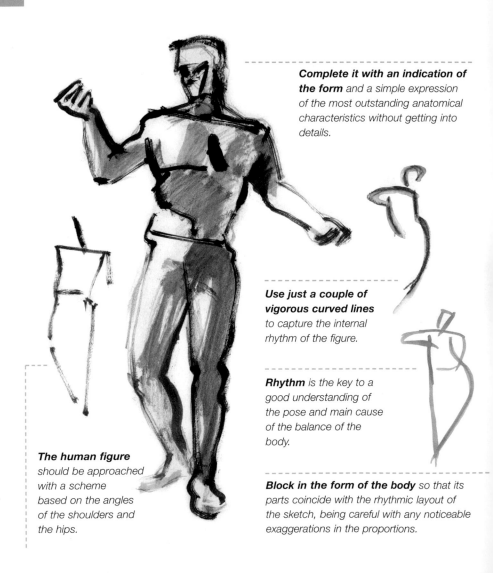

Complete it with an indication of the form and a simple expression of the most outstanding anatomical characteristics without getting into details.

Use just a couple of vigorous curved lines to capture the internal rhythm of the figure.

Rhythm is the key to a good understanding of the pose and main cause of the balance of the body.

The human figure should be approached with a scheme based on the angles of the shoulders and the hips.

Block in the form of the body so that its parts coincide with the rhythmic layout of the sketch, being careful with any noticeable exaggerations in the proportions.

Drawing the Figure for Painting

Drawings for later painting should not be detailed anatomical studies of the body. The key to making a good figure drawing is found in a very detailed observation and in an economy of lines. The preliminary sketches for a painting should have the single objective of translating the complex forms of the body into a recognizable and convincing structure. It is best to capture the attitude, the positions of the legs, the gestures of the hands and the arms, in effect, the corporal expressions of the individual, in just a few lines. It is best to use charcoal or other volatile media because they usually require much correction.

Avoid Details and Capture the Rhythm

When making the drawing before painting it is important to capture the main forms and the rhythm of the figure. The tension in a pose is manifested in the rhythm, in other words, with an imaginary internal line that creates a sense of the fluidity, expression, and dynamism of the body. In this way, the essential gesture of the figure is suggested in the natural form. You must avoid the details, like fingers, facial elements, wrinkles in the clothing, and such things. The correct approach is to resolve them in generic forms or in directional lines that from the beginning offer a vision of the total figure, especially if you take into account that the first brushstrokes will hide all this information while tending to unify the painting.

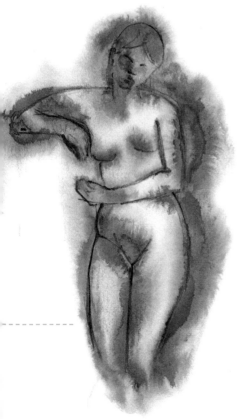

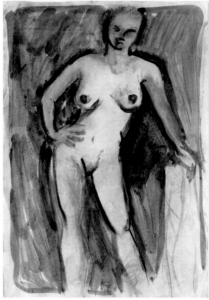

On a preliminary sketch drawn with a charcoal stick, we have painted a nude with color pastels and silhouetted the form with light red ink.

The Attraction of **Animals**

The great variety of species in the animal world present the artist with an infinite range of forms, structures, colors, and textures. More than in any other case, the representation of an animal requires a very large dose of memory, since the main challenge is that the models are constantly moving in unpredictable ways. This can usually be resolved with a linear approach to which is added a suggestion of shading, after which you will reinforce the lines and add middle tones.

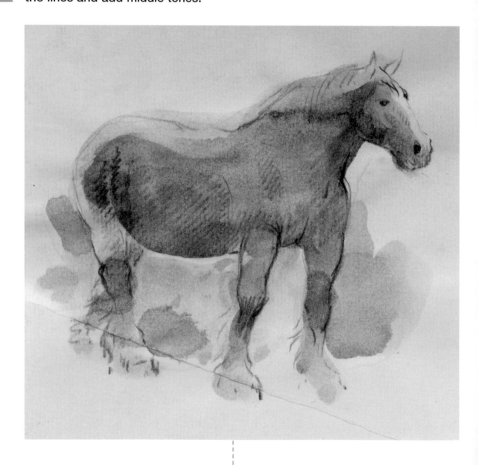

Animals are usually approached with a sinuous line made with a graphite pencil, which is reinforced by light shading with watercolors.

Combining pencil with a very transparent wash creates a strange symbiosis of drawing and painting. The fine layer of color shows the small hatch lines on the side of the animal.

A Quick and Loose Drawing

Many artists use gestural lines in an intuitive manner to draw animals. Drawings of this type do not attempt to make a detailed portrait of the subject but to capture its spirit, its essence. Animals are rarely still, and they are not under the artist's control, so it is best to work fast, and this means sketching quickly. It is a good idea to carefully observe the animal before drawing, and if necessary make a preliminary sketch to study the basic forms of the head, the trunk, and the extremities.

A Combination of Line and Color

The best way to draw animals is to make note of the volume and the variations in color. Therefore, it is very helpful to make some color sketches using a bit of diluted paint, and taking full advantage of all the possible shades you can make with it. The combination of the painted washes and the lines lend the drawing a spontaneous, impersonal, and dynamic aspect. The first washes should be accurate and graceful, since they have to define the pictorial approach to the work. When you are blocking in the brushstrokes that represent the shadows, completely omit all details and reinforce the structure of the animal's body, its gesture, and its volume.

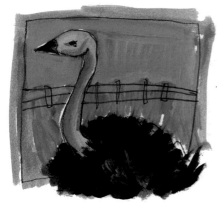

This ostrich was drawn quickly and sketchily with thick oils. The overlaid graphite lines define the form and situate the bird in the space.

The line outlining this horse was drawn directly with black oil paint, and it lends much presence to the work. The outline of the animal is thick and reinforces the impact of the model.

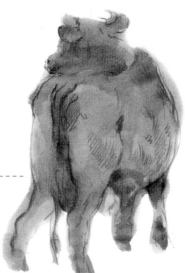

Preparing the **Portrait**

Before representing the features in a portrait, you must find what is unique or particular about the subject. The preliminary drawing should carefully articulate the structure of the face to bring out the person's essence in the surface of the face and thus make the later painting process easier. If you do not do this, the drawing will not unify the portrait, and the features will be too sharp and not well connected to each other. A face is something more than the sum of two eyes, a nose, and a mouth, and any success will be due to a good preliminary structure.

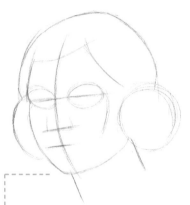

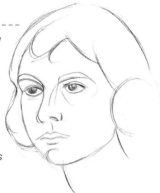

The approximation of the features *and the facial particularities of the model should be slow and progressive, so focus on synthesis, and leave the details for last.*

Before you draw the features *of the model you must lay out a convincing facial structure based on the observation and synthesis of the forms.*

When the structural articulation of the face is convincing, *each feature can be developed in greater detail and the first washes of color applied. Here we are using watercolor.*

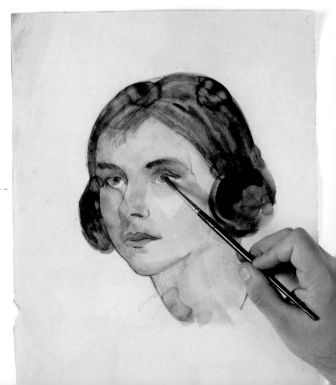

First the Structure

The portrait establishes the conditions for representing that which is most notable in the face, using graphic codes to create or materialize its appearance. The obsession that artists have for creating a resemblance to the model encourages errors and causes them to forget that the drawing comes before the painting, and this condition determines the constructive process. Therefore, it is best to begin by studying the structure of the face and constructing it with simple, very schematic shapes. The distance between the eyes, the length of the nose, and the size of the forehead, should all be well defined from the beginning.

Then the Features

The formal likeness between the portrait and the model is created by a series of tiny features related to the selection of singular physiognomic aspects that should be noted in the preliminary layout of the features. Then the drawing will become somewhat more accurate, but not definitive. Remember that you are learning to make a preparatory drawing for a painting, which means that most of the details and anatomical particularities should be resolved with the paintbrush. In this sense, the areas of the eyes and mouth are the fundamental part of the face and are mainly responsible for the similarities with the person being painted.

When painting with oils it is best to make a preliminary sketch with charcoal. The applications of paint should be opaque and assembled together to configure a colorful puzzle.

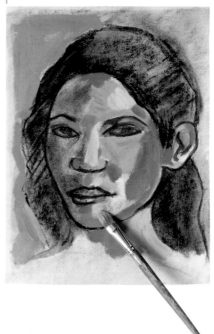

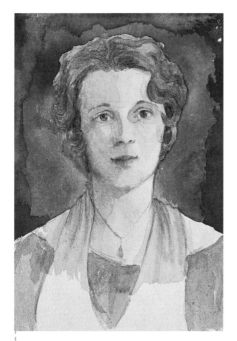

A front view of the model is easier for calculating the features like the height of the mouth, the distance between the eyes, length of the nose, the hairline, etc.

LET'S EXPERIMENT

The First Steps
of a Portrait

Children are the best subjects for beginners, because their features are not as sharp or hard as those of an adult.

1. *Use a stick of charcoal to draw the structure of the head. The hair and the clothing should be indicated with the side of the stick.*

① ②

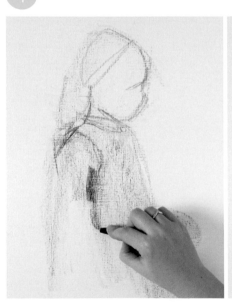

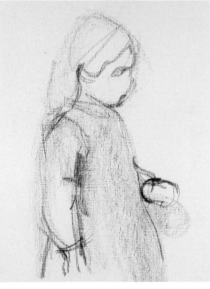

2. *With the point of the stick, a second approximation is now made of the face, and the arms and hands are located. The lines should be quite sinuous, even leaving some areas unfinished.*

3. *When the structure of the figure and its proportions are convincing, a much more accurate drawing is made, adding more pressure with the stick.*

A portrait is the most intimidating subject for the amateur painter. Capturing the facial expression and a likeness of the model is only in reach of more experienced artists. The secret resides in the preliminary drawing. In this exercise we demonstrate the simplest and most practical way to approach it.

It is enough to focus on certain aspects that will help you create a good base so you can then enjoy the painting process and apply the colors without worry. The final result, which looks a little unfinished, is useful for understanding how to construct the drawing and how it is integrated into the painting.

4. Wet a hog-bristle brush with just turpentine, and go over the charcoal drawing. This step acts to fix the charcoal powder so it will not muddy the colors.

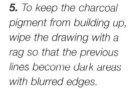

5. To keep the charcoal pigment from building up, wipe the drawing with a rag so that the previous lines become dark areas with blurred edges.

6. The best way to capture the outline of the figure is to paint the background with different tones of very light green, ochre, and gray. The drawing is reinforced with new charcoal lines and blue brushstrokes.

7. Paint the dress by juxtaposing crimson and gray violet tones. Then paint the arms and start on the face. The strokes of color should match up like pieces of a puzzle.

8. The figure will emerge gradually. The paint should be applied thickly and the brushstrokes are not very refined or polished. You should avoid any details.

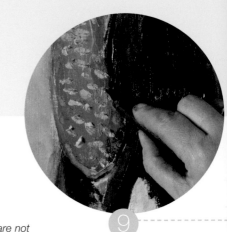

9

6

7

8

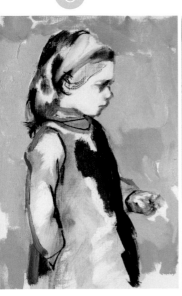

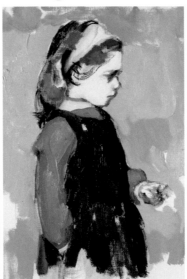

THE LINES OF THE DRAWING ARE INTEGRATED INTO THE PAINTING

9. *Some of the brushstrokes become more defined lines, like in the hair. Others can be retraced with charcoal. The lines of the drawing are again integrated into the painting.*

10. *Soften the colors on the face by lightly blending them, using a brush charged with less paint. Apply new charcoal lines to outline the chin and to suggest locks of hair.*

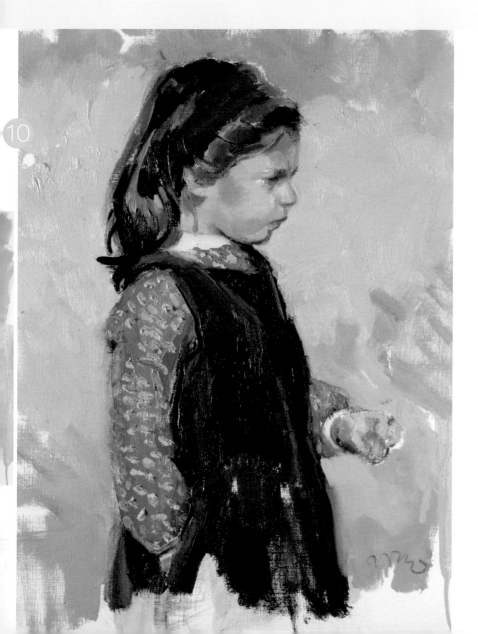

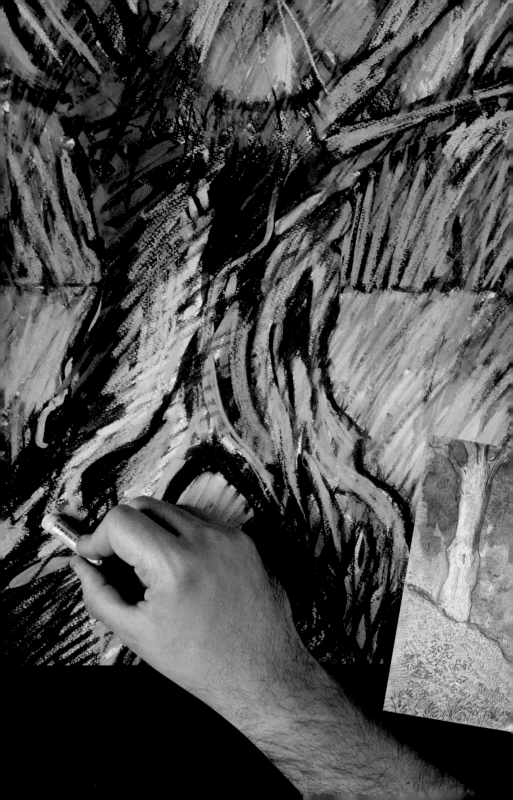

Drawing **Applied to the Painting**

Up to this point you have studied what a preliminary drawing for a painting should be like, the strategies, varieties, and the ways of making them in a quick, comfortable, and effective way. In this next part, the objective is different; it is about trying to strengthen and integrate the drawing in the painting, as equals. In this way, the line complements the brushstrokes of oil, watercolor, or acrylic, and vice versa.

These are two different media that blend into one. The drawing contributes emphasis, structure, and strength, while the paint is seen as the main carrier of feelings, depth, and subtlety. The line of a charcoal stick, pastel, or wax crayon opens a wound on the fresh surface of a painting to add greater graphic richness to the work, and why not say it, a somewhat more daring and modern resolution to the final interpretation.

The Color **Drawing**

This is one form of representation that does not attempt to hide the drawing underneath dense layers of paint; on the contrary, its objective is the symbiosis of the line and the wash, so that both the drawing and the painting are visible at the same time. Given that the paint must be quite transparent, this painting technique lends itself more to work done in watercolor, although this does not rule out other painting media as long as they are applied diluted.

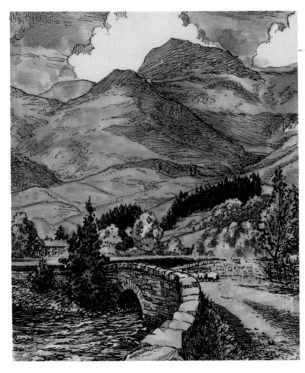

Coloring consists of painting each area of the drawing with a thin layer of paint. This technique is commonly used by illustrators.

Watercolor washes barely hide the lines of the preliminary drawing, and the two blend together, although the strength of the drawing is much greater than that of the watercolor.

Painting or Coloring?

What is the difference between "painting" and "coloring"? Although the two words seem to be synonyms, we emphasize their meanings to highlight how they differ. Painting is a process in which a preliminary drawing that serves as a guide is covered with several layers of paint, which generally results in hiding it totally or partially, because the object is to create a pictorial representation of the model based on brushstrokes, gradations, and contrasting colors. Coloring does not try to hide the drawing but gives it meaning by adding light layers of color that complement the lines, which remain visible when the work is completed. Coloring is very common among illustrators.

Graphite or Watercolor Pencil?

Artists who habitually draw with watercolors make sure the graphite pencil does not make a very dark line so it will be more or less hidden under the thin layers of watercolor paint. But here we are talking about something completely different; instead of a pencil you can use a 2B or 4B graphite lead to draw the subject, with thick, strong lines. First make a clear drawing, working with the lead somewhat angled to create thicker lines. Over this clearly defined drawing add some color, which should at no time be saturated or thick. The final result is a very strong work, where the colors harmonize well.

The entire preliminary drawing was done with a 4B graphite lead, strongly marking the outlines and adding some shadows, and it was then completed by coloring it with watercolor.

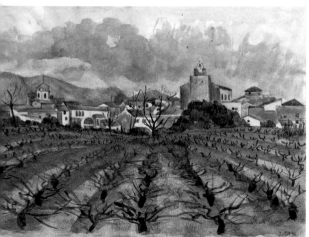

Although they are less common, diluted oils can also be used for coloring, since they neither dilute nor alter the graphite pencil lines.

Brush **Drawings**

A brush charged with ink is one of the most widely used drawing media for making gestural sketches, since it makes very fluid marks and allows better control of the line. Although drawing with dry techniques, like pencil or charcoal, is the basis for a rational study of forms, the experience of drawing directly with a brush is based on intuition and on impulse as creative expression.

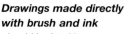

Drawings made directly with brush and ink should be intuitive, capturing forms in a poetic manner with long, strung-together lines.

A model sketched with a brush has much more presence than a graphite or chalk line and it integrates better with the color that is added to the representation.

Quick Brushstrokes

Drawings made directly with a brush are based on a rhythmic exaggeration of the line. They are drawn quickly, as if the lines were part of an inscription made up of successive gestural marks. A gestural drawing made with a brush does not attempt to describe the model in detail but to capture the essence with quick brushstrokes. The gestural motions allow the artist to achieve spontaneity and agility with the brush. After the brush drawing is dry, it can be completed with colors as if it were made with graphite or charcoal.

Varied Brushstrokes

Lines made with a brush should not be stiff; on the contrary, the tip of the brush should twist and flatten in response to the gestures and movements of the hand. The best brushes for drawing with ink or liquid paint are sable hair or synthetic brushes with round tips. The natural brushes are better for inks, dyes, and watercolors, and the synthetics for acrylics and oils. They should be very absorbent and hold a large amount of diluted paint, since this guarantees a more fluid and longer line. Applying more or less pressure and angle to the hair of the brush will vary the thickness and intensity of the line.

Brush drawings offer different possibilities, depending on the angle and pressure applied to the brush and whether it is charged with a large or small amount of ink. The tip will make a fine line (a), but with more pressure the line becomes thick (b), and a brush with a small amount of ink will make textured lines (c).

Soft brushes with round tips and ink, in this case india ink, are the most usual combination, although diluted oil and acrylic paint can also be used.

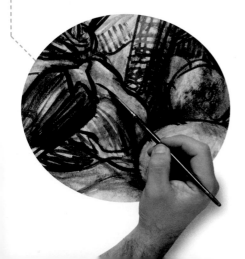

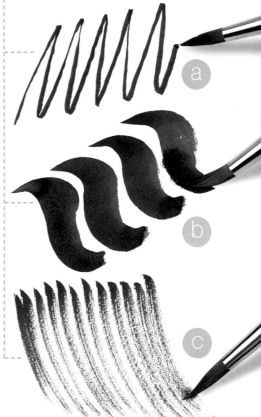

Drawing Lines **on Fresh Oil Paint**

Can you draw over fresh oil paint? Traditionally it was thought that drawing was always part of the preliminary steps in a painting, much earlier than the application of any kind of paint on the support. However, here we demonstrate that there are several strategies for drawing that the painter can use in the final phases of the painting, for creating textures, highlighting a profile, or simply adding more graphic variety to the work. Let's look at some examples:

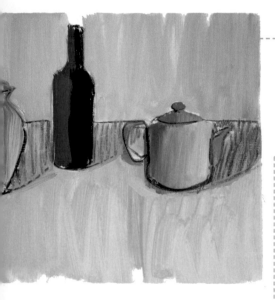

Here are graphite lines on an oil painting. The drawing was added at the end of the painting to bring back outlines and forms that were lost during the painting process.

Short lines are made here with a stick of charcoal on a layer of fresh oil paint. The intention is to separate the edges of the leaves.

Oils can easily be combined with oil pastels because both have a similar consistency. The pastel sticks are used here to draw small shoots and the veins of the leaves.

Scratching the Surface

Lines made with charcoal, chalk, pastel, and oil pastels can be added to a painting during the final phases of work to bring back lines that have disappeared under the brushstrokes. If the layer of paint is thin, the pigment in the line will adhere easily to the surface of the support. The dust of the pigment will adhere to the wet paint. When the layer of paint dries, the lines of the drawing will be permanently preserved and a fixative does not have to be used. If you use the rounded tip of a spatula to make the drawing it is known as sgraffito.

Cleaning the Point

If the layer of paint is very thick, the simple action of the point of the stick or the metal spatula causes incisions like a plow in a field. It makes a deep relief line in the paint. Every time you use drawing media, especially the dry ones like charcoal, pastel, and chalk, it is a good idea to carefully clean the point, because if you allow the paint to dry on the drawing stick it will not be able to make new lines. Just wipe the stick off with a piece of absorbent paper after drawing each line. This will also keep you from accidentally transporting a color from one part of the painting to another.

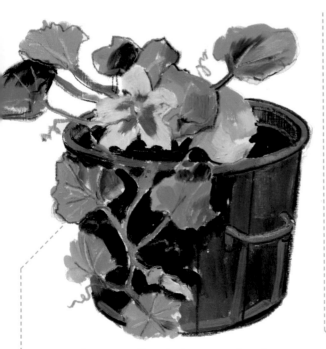

This painting exemplifies the incorporation of drawn lines that should be made while the oil paint is still wet. If the paint is dry there is a risk that the lines will not be permanent.

Oil pastels have a greasy consistency. They make a line that integrates very well with oil paintings.

Still Life
with **Sgraffito**
and **Acrylics**

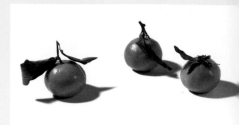

The subject of this still life is composed of three mandarins that project an eye-catching shadow on a white surface.

1. First cover the support with a layer of cadmium red paint, to which has been added a little gloss gel to give it more body.

2. Let the layer of paint dry, and cover it with white paint mixed with gel retarder to keep the acrylic paint from drying too quickly.

In this creative project you will mix painting techniques with others that are more related to drawing to achieve an interesting balance between line and color. Since the paint is mixed with different gels and pastes to create a dense and textural work of art, you should work on a rigid canvas board since it will better support the scratching of the sgraffito and the accumulation of thicker paint applied with a spatula. The result is a fresh, lively, and dynamic work.

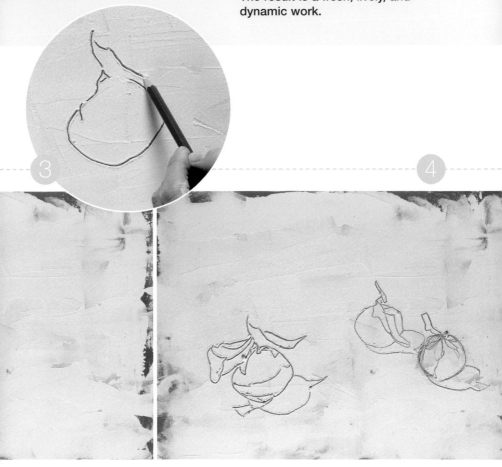

3. Draw the mandarins on the surface of the still-wet paint with the point of a red pencil.

4. The pencil will penetrate the still-fresh white paint and create a sgraffito that shows the base color. Keep cleaning the point of the pencil once in a while with a rag to keep the paint from accumulating.

At the same time, prepare another support where you can practice several variants of the same subject. After comparing the results, continue working on the one that is the best representation.

BALANCE BETWEEN LINE AND COLOR

5. Let the white paint dry, and paint the mandarins with a spatula, using a mixture of yellow, orange, and red. Add gel to the paint to increase its volume, especially to the green for the leaves.

6. Continue building up the mandarins with a lot of paint in different tones. Do not apply too much pressure with the spatula to avoid dragging the colors underneath.

7. *It is a good idea to use a small spatula on the leaves, combining two shades of green mixed with gel.*

8. *Use new additions of green to finish the leaves. Then add a point of light or reflection to the mandarins with white paint directly from the tube. Be careful that the white paint does not mix with the surrounding colors.*

Drawing on
Fresh Oils

A few pages ago we studied the relation between lines created with different drawing media combined with water-base paint. Here we will study the reaction of these same

Lines made with pastel pencils should be dark. *Even so, they tend to blend with the paint, which explains why they have a more violet tone in the center.*

Drawing with a pastel stick over paint is easier, *although the line tends to get pasty in the center and the outlines remain dusty.*

A hard graphite lead acts like a plow *that moves the paint and causes it to accumulate along the sides. You must press hard on the support to create a darker line.*

When the layer of oil paint is very thick, *charcoal can only be applied with the point of the stick. When it is finer, like here, the side of the stick can even be used.*

drawing materials on the creamy surface of the oil paint. When you work on a thicker layer of paint, despite a greater difficulty in making dark lines, the graphic possibilities and combinations are more varied. Not only are you drawing but also scraping and creating deep grooves, noticeable changes in the uniformity of the paint.

When oil pastels enter into contact with the greasy surface of the paint, *they melt and easily mix with the underlying color.*

You do not always have to add lines to draw; *you can also draw with sgraffito, which means removing part of the paint with a blade or a spatula.*

Make sgraffito marks with the rounded tip of a spatula *to emphasize the relief effect of the paint. The play of light and shadow causes them to be more visible.*

If you want sgraffito lines made on a layer of light colored oil paint to be visible, *you should take the precaution of painting over a colored background.*

Ferdinand Hodler
(1853–1918)

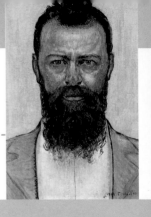

Hodler made paintings charged with symbolism characterized by intense colors and extremely idealized forms.

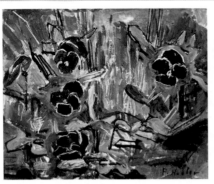

1. To paint with Hodler's technique, first draw the subject with charcoal. Then, quickly paint each area with diluted oils.

Pansies, *1915.*
This floral still life was made in the last phase of his life. The painting has a very expressionistic look, with strongly colored and more stylized forms. The model is reduced to essentials, and the drawing is strengthened with the sgraffito technique. He used the handle of the paintbrush to make lines that outline the flowers and add greater visual interest to the still-fresh surface of the oils.

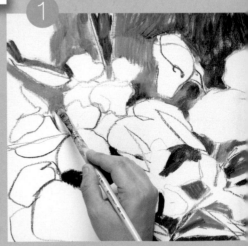

THE STRENGTH OF SGRAFFITO

The Swiss artist is considered one of the principal painters of Central European Symbolism of the late nineteenth century, influenced by a personal concept of the world and dominated by the principles of symmetry and rhythm. After an early phase of uninspired landscapes, he moved toward Art Nouveau–style painting, with flat, repeated forms and rhythmic designs. In the final years of his life he became one of the most innovative muralists of the era. Before his death, his work evolved toward more vigorous and impassioned brushwork that presaged the coming Expressionism.

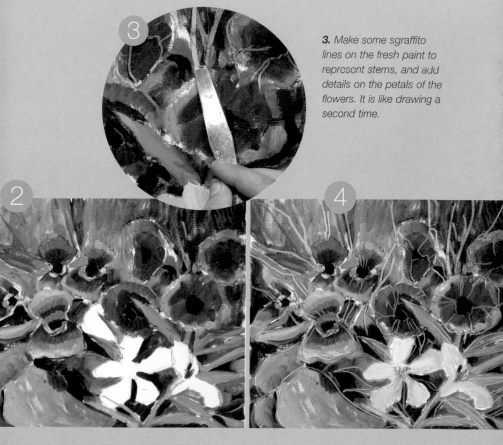

3. Make some sgraffito lines on the fresh paint to represent stems, and add details on the petals of the flowers. It is like drawing a second time.

2. Paint each area with opaque paint, using a range of browns in the background, luminous greens on the leaves, and warm reds, crimsons, and oranges on the flowers. It does not matter if there are small bare areas that show the white support underneath.

4. The combination of colors and thick and thin paint with the scraped lines made with the metal spatula give the painting a very interesting finish, with a perfect balance between line and color.

Nib Pen, **Reed Pen, and Wash**

The nib pen, like the reed pen, has a long tradition as a drawing tool or medium. Both help you put into practice a series of specific ink techniques that are at their best when combined with color washes. The wash adds new luminous and chromatic qualities to the drawing, while the line that is made by these instruments is the main defender of the textures and precise details.

The metal nib pen makes a fine line, thin and very intense, that allows you to resolve very small elements and details.

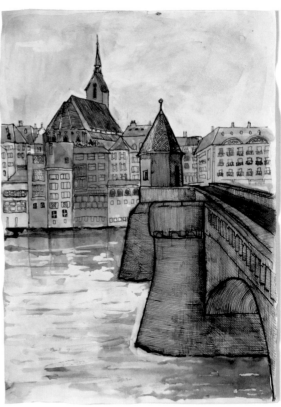

Shading with a nib pen is done by overlaying or crossing several hatch lines.

In architectural drawings the metal nib pen gives you the opportunity to work in detail. Later, the scene can be completed by coloring it with watercolor and gouache.

The Fine Line of the Nib Pen

The nib pen draws one of the finest and darkest lines possible. It can be as simple as it is complex, since it can make a subtle line or a perfect hyperrealistic drawing. With the nib pen you can create different widths within a single line, depending on the flexion of the nib. An ink drawing can contain very elaborate line work, which can be complemented by adding values with washes of either ink or watercolors. Many varied effects can be created. Sometimes the shadows can be reinforced and details added in areas with a brush; other times a line can be completed with gradations of color and contrasts that transmit a feeling of volume and body.

Reed Pen Drawing

The reed pen is a much more rudimentary instrument than the nib pen, but many artists appreciate it for its crude line and the freedom it gives them in making sketches. Depending on the shape of its point, pointed or beveled, the line can be thick or thin. The line made with the point of a reed pen is soft par excellence, far different from the hard lines of the metal pen, and it allows you to alternate dark wide lines with thinner lighter ones that are similar to those made by a marker that is running out of ink. These depend on two basic conditions: the pressure applied and the amount of ink it is able to hold.

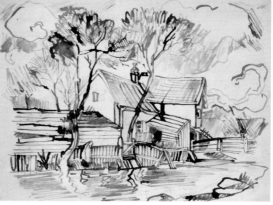

The inks for drawing with reed pens can be of various qualities, but when diluting them it is important to always use distilled water to avoid the chlorine and calcium.

The reed pen line is thicker. The ink you use can be diluted with a little water to reduce its intensity.

The reed pen is much more crude than the nib pen and the intensity of the line is more irregular, although this is not a defect; rather it is one of its main virtues.

Architectural History
with Nib Pen and Watercolors

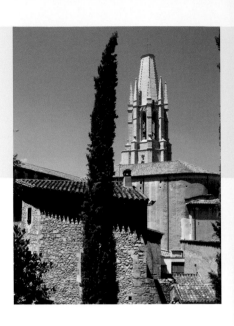

It is important for the subject to have an outstanding architectural element, with attractive and stylized shapes, if possible. Gothic architecture has these characteristics.

①

②

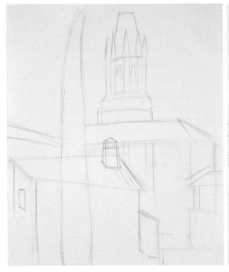

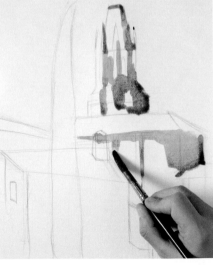

1. The sketch should be done in pencil. It is a matter of projecting the structure of the buildings based on simple geometric shapes. It is not necessary to draw the details.

2. Begin painting the shaded parts of the buildings with a mixture of ultramarine blue and a touch of crimson. After the first washes the pencil lines will still be visible.

Architectural drawings require the greatest skill of artists in judging the perspective and especially his or her ability to create specific textures and describe intense contrasts of light and shadow. In many cases, the details and embellishments are important to the drawing and become a fundamental element in

the overall work. The symbiosis between the watercolor washes and the delicacy of the lines made with the metal nib pen are a clear example of this. The variety and precision of the lines and marks that can be made with a nib pen are ideal for detailed drawings.

4. Wait a few minutes until the blue tones of the shadows are dry, and cover the more illuminated façades with a mixture of very diluted crimson and ochre.

5. The watercolor was applied very wet, allowing soft blending between one color and another to avoid harsh contrasts. Paint the blue of the sky when the paper is dry so it does not invade the spaces occupied by the buildings.

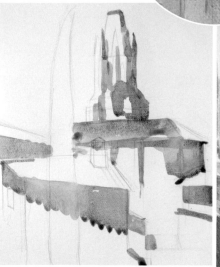

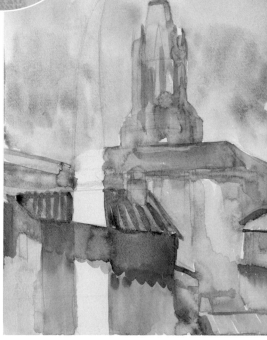

3. For the moment, the most illuminated areas should not be painted. Just worry about representing the shadows projected by the buildings.

6. Before starting to draw with the pen, paint the vegetation in the foreground with sap green and cadmium yellow. These washes should be more contrasting than the previous ones.

8. Both the decorative and the functional architectural details can be as exciting to draw as the buildings themselves. The still-visible pencil lines are guidelines for the inking process.

7. After the paper is completely dry, start drawing the bell tower with very fine lines using dark violet, which will create a base over which you can later incorporate the intricate architectural details.

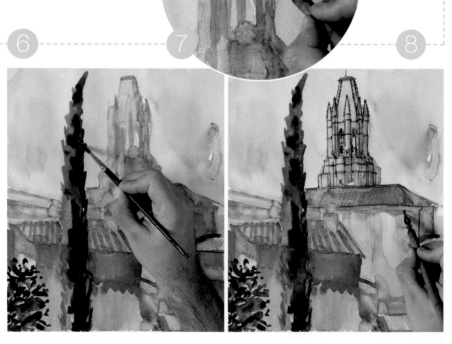

9. The nearest rooftops require some more details. The lines made with the pen should be dark and heavy. If necessary, you can go over the same lines twice.

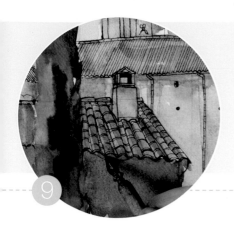

10. The windows and openings are also interesting material for the artist, since they can be used as a compositional resource and for filling empty spaces, but it is a good idea not to overuse them.

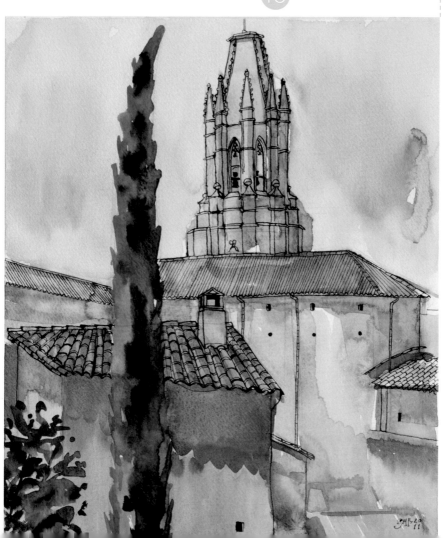

Oil Pastels and **Oil Sticks**

All drawing media that have wax and oil binders are included under this category. They are ideal for work requiring a strong and colorful line and very suitable for work that calls for a simple and loosely sketched treatment. Both pastels and oil sticks (which are much more intense and thicker than the former) can be worked with a brush and diluted with solvent as if they were conventional paints.

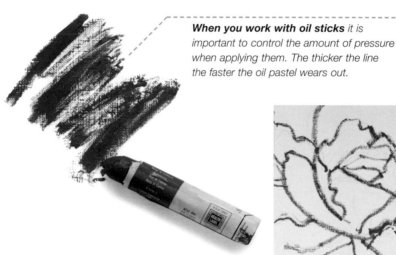

When you work with oil sticks *it is important to control the amount of pressure when applying them. The thicker the line the faster the oil pastel wears out.*

Oil sticks can be used for the preliminary drawing *of any oil painting. The lines will be uneven but sure.*

We are going to paint a vegetable that was previously sketched with bright red. *The idea is to provide contrast for the dynamic greens that will be used.*

Oil Pastels or Wax Crayons

These sticks have a combination of pure colors and oils and wax. Since they contain an oil binder, the lines are more resistant and adhere well to any surface. These paints are hard to blend with the fingers so a brush charged with turpentine is used, which makes this medium resemble oil paints. This characteristic makes oil pastels suitable for drawing as well as for painting. The vast potential of oil color pastels far outweighs their shortfalls.

Oil Sticks

In reality, these are oil paints but in stick format. They can be used to model forms using lines, in other words, their linear structures. By rubbing the sticks against the canvas, the paint acquires some fluidity, making it easier to apply and providing lines that are intense and uneven. The large amount of oil-binding material contained in them prevents the colors from cracking. Brushing the lines with a brush charged with turpentine dilutes the paint and reduces the intensity of the lines. They can be used before drawing with oils or added later with thick lines applied with the stick on the surface while the paint is still wet.

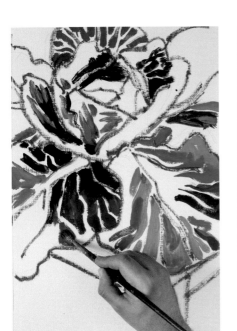

We painted every empty space with oils, making sure not to press too hard on the line with the brush because it is very creamy and tends to dilute easily.

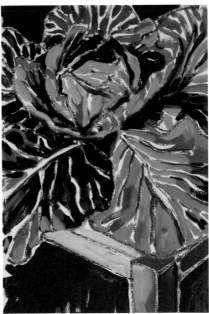

We finish applying the various tones of green and continue painting the table and the background. The combination of the lines done with the stick, the areas of color painted in green, and the white spaces of the support give this interpretation a very lively and expressive character.

Pastels and Gouache: A Perfect Combination

The ability to combine the dry pastel lines with paint can create one of the most colorful and pleasing combinations imaginable. The lines drawn with pastel colors can be used for the preliminary drawing, solidify the forms in the work, and define the areas painted with one color from the areas painted with a different color. Then, gouache fills up the spaces and blends with the lines of pastel since both media are compatible.

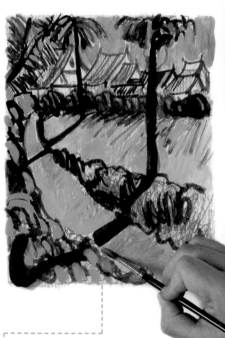

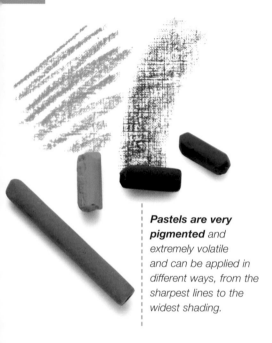

Pastels are very pigmented and extremely volatile and can be applied in different ways, from the sharpest lines to the widest shading.

When painting with gouache you do not need to cover the underlying pastel drawing completely. It is important to find a precise balance between the two, combining crosshatched lines with wide areas of solid color.

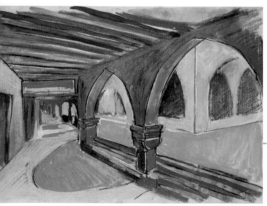

First we draw the perspective of this landscape with charcoal and bright pastels. Then we fix the drawing with a spray and begin to paint with gouache.

An Ally of Pastels

Gouache can be a great ally for the painter who likes to draw with charcoal and pastels on boards or heavy color papers. It can be used very similarly to watercolors with the difference that the colors are more opaque and saturated, so they combine very well with the lively and bright lines made with dry pastels. It is best to begin by drawing with charcoal and with two or three pastel sticks. The lines can be different and have various degrees of intensity; however, no shading is possible because a surface saturated with pigments or fine pastel dust makes the subsequent application of gouache difficult.

A Precise Drawing

Oils and pastels can be used to do very spontaneous and sketchy preliminary drawings; this is possible because generally the paint ends up covering them all completely. With pastels, it is important to do a very well-defined drawing, a good starting point from which to build the structure of the areas of color. Gouache requires a drawing of greater precision. This is because the colors are applied by areas, avoiding covering the lines made with pastels too much. The areas of color will try to complete the information provided by the pastel drawing with more or less flat colors. The paint is contained within the empty space defined by the lines.

Once the paint is dry, you can add new lines with pastels to highlight the profiles or to make the lines stand out.

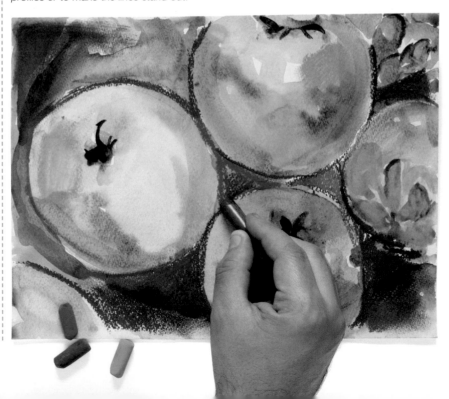

Vincent van Gogh
(1853–1890)

From the drama of his first scenes to the simplicity that characterized his last work, Van Gogh announced the beginning of Expressionism.

Landscape with Bridge Across the Oise, *1890.*
Van Gogh's technique promulgated the exaggeration of the lines of the preliminary drawing. He outlined them with heavy blue lines to strengthen the forms and when combined with the color, to better suggest the expression of feelings and emotions. Then, instead of reproducing the real model exactly, he filled in the areas inside the drawing with short brushstrokes charged with paint, to add a greater degree of expression. He achieved this effect with nervous lines painted with steady rhythm throughout the surface of the canvas.

THE BEGINNING

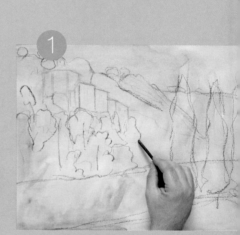

1. We cover the background with very diluted ochre paint. It is better to use acrylics so the paint dries faster. We do the preliminary drawing dry with a charcoal stick.

2. With oil paint highly diluted with turpentine, we go over the previous drawing so everything is outlined with thick and intense lines of titan blue. This will be the foundation of the painting, and it will not disappear when we paint.

3. We paint each area with more compact colors, being careful not to cover the previous lines and letting the ochre background remain visible throughout the entire surface.

Van Gogh is considered one of the great masters of painting and the precursor of twentieth-century painting, especially among the Expressionists and the Fauvists. His work was characterized by the use of color and for the perfect balance between lines and areas of color, as well as for the use of intense lines.

Van Gogh was a drawing master and very prolific. He considered drawing an integral part of his painting and his last work done in Auvers-sur-Oise does not leave any room for argument. It is difficult to find a body of drawings among his contemporaries that equals his in number and quality.

)F EXPRESSIONISM

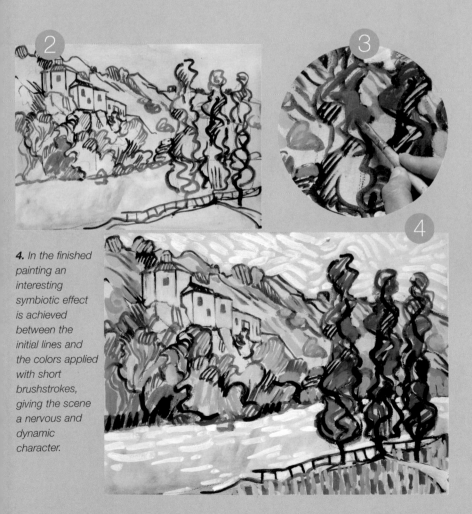

4. In the finished painting an interesting symbiotic effect is achieved between the initial lines and the colors applied with short brushstrokes, giving the scene a nervous and dynamic character.

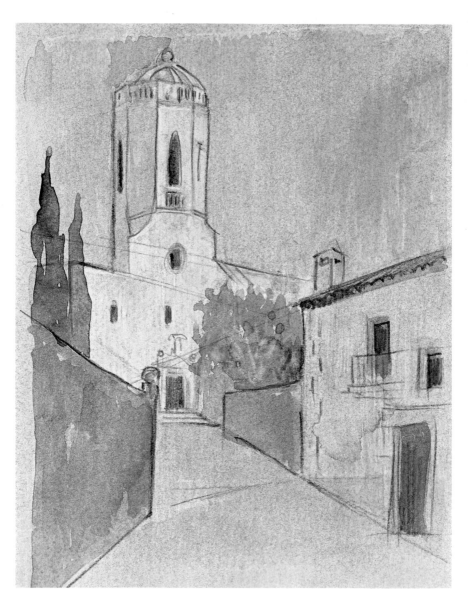

Drawings should not be considered the result of an artistic activity that is separate from the structure of the painting, whether it is done with oils, acrylics, watercolors, or gouache, but as objects intimately related to the work, because often they are the testimony of the complete creative process that could rarely, if ever, be externalized in any other way.